Learning
by Heart

Learning by Heart:
Teachings to Free the Creative Spirit

"I think on some mystical level that Jan Steward and Corita Kent were joined at the hip in the creation of *Learning by Heart*. The mystery of life is apparent in the creative expression of their work together. This book presents unique ways of 'seeing' and manifests the power of creativity in very real and doable ways. It becomes both an inspiration and a road map for human development. We have entered a time on this earth where the quality of our creative ability may be the deciding factor between the extinction or survival of our human species."

**Bob Bates, Artistic Director and
Co-founder of Inner-City Arts**

"Through *Learning by Heart* a great teacher lives and speaks with us. This is a book to grow on, a book that can make us better designers, better communicators, and better human beings."

**Ashoke Chatterjee, Former Executive
Director, National Institute of Design, India**

"In this graceful book Jan Steward conjures the inimitable spirit of Corita Kent and Corita's high-flying and break-dancing ideas."

**Harvey Cox, Thomas Professor of
Divinity, Harvard University**

Learning by Heart

Jan Steward and Corita Kent

ALLWORTH PRESS
NEW YORK

12 11 10 09 08 5 4 3 2 1

Published by Allworth Press.
An imprnt of Allworth Communications, Inc.
10 East 23rd Street, New York, NY 10010

Cover design by Jan Steward, typography by Paula Rao
Interior design and page composition by Jan Steward
Interior typography by Unicorn Publishing Services

LIBRARY OF CONGRESS CATALOGING-IN-PUBLICATION DATA
Corita, 1918–1986.
[Learning by heart]
Learning by heart : teachings to free the creative spirit / by Corita Kent and Jan Steward.
p. cm.
Originally published: New York : Bantam Books, 1992.
Includes bibliographical references and index.
ISBN-13: 978-1-58115-647-8 (alk. paper)
ISBN-10: 1-58115-647-2 (alk. paper)
1. Creation (Literary, artistic, etc.) 2. Creative ability. 3. Art—Psychology. I. Steward, Jan. II. Title.
N71.C664 2008
701'.15—dc22
2008034419

Printed in the United States of America

CONTENTS

There was never a time when I did not exist, nor you, nor any of these kings. Nor is there any future in which we shall cease to be.

Bhagavad Gita

For Corita Kent and Ray Eames
And for my mother, Paula England

FOREWORD

It was in 1979 on a trip to Little Tokyo in Los Angeles when Corita asked me to write this book. We would work together. It would be quick and easy. It was neither. She lived in Boston and I in Los Angeles. We worked by letter and phone and progress was painfully slow. We worked for hours on content and every few meetings the concept would change–sometimes radically.

As the years passed, Corita and I argued, laughed, and hoped for enlightenment. I continued to plod through many versions of our book. Sometimes we thought it would be named "How to Walk on Water" or "The Star in the Celery." It was like trying to count and stack a forest stream in order to explain its singing. Finally, with the help of Andrew Zega and Toni Burbank at Bantam, a draft was finished. We looked forward to working together on polishing the text and, most of all, on the visual aspects. Corita had said the book must be only black and white to make it less expensive. She also was adamant that I not use her work as illustration. It had been a law in her classes that we must not use as sources the work of other artists. The exception to this law was anonymous folk art, which was the choice for source. When I worried that the book wasn't right, she laughed at me and said it wasn't the Bible or *Gone With the Wind*. "It's what I want," she would say firmly.

In early 1986, we planned to soon finish at least the concept. I would go to Boston in the summer and she would come to L.A. in the fall and winter. But in the spring she became ill and in September she died.

The book was published in 1992, six years after her death, and has not been available for many years except in second hand marketing. Prices range from $45 to $250 for this little paperback that cost $12.95 when it was published. There are no changes but a few additions.

Given the renewed and growing interest in Corita, following the forward to this edition is a brief biography of the artist written for this book by her former art student, Barbara Loste. At the end of the book is a chart for teachers showing assignments that would apply to specific National Frameworks and Standards for Visual Arts and a statement by educator and administrator Susan Friel. Though it was not the intention to write the book for teachers specifically, the response has been so great in many areas of teaching–not just art–that we decided to add this material.

2007 has seen a tremendous rise in interest for Corita and her work. A new publication, *Come Alive! The Spirited Art of Sister Corita*, brings us brilliant visuals and essays by author Julie Ault and Fr. Dan Berrigan, Corita's dear friend. A superb film by Baylis Glascock, *Corita, On Teaching and Celebration*, shows her in the classroom, the Mary's Day experience, her art, and includes various interviews. Both are available through the Corita Art Center in Los Angeles. For information on Corita's shows, sales, and other activities see the Corita Web site *www.corita.org*.

Please forgive a major mistake on page 114 where I refer to "the two presidents." Of course, Benjamin Franklin could have been, but never was president.

Jan Steward
July, 2008, Los Angeles, CA

CORITA: A BIOGRAPHY

"We have no art. We do everything as well as we can."

Corita Kent (1918–1986) was a major 20th-century American artist and a charismatic teacher at Immaculate Heart College in Hollywood, California. Corita believed that everyone, and every student, was capable of great creativity. As one of her art students in the late 1960s, I remember how Sister Corita changed the potentially stuffy classroom atmosphere into a cauldron of queries and assignments, encouraging students to question most of what we thought we knew about art, or about most other things. Corita was inspired by the bits and pieces of life around her, from billboards and newspaper headlines to the international folk art that was keenly amassed by Sister Magdalen Mary ("Maggie") who preceded Corita as chair of the art department. One of Corita's favorite teaching tools was a *finder*, a scrap of cardboard with a window in the middle through which students discovered design elements in unexpected places—the supermarket, a gas station, cracks in the sidewalk. She immersed students in flow—the creative practice of observing and working with single-minded concentration—and overflow, doing lots of it. Learning art Corita-style meant serious observing and serious play.

Corita was born Frances Elizabeth Kent on November 20, 1918, in Fort Dodge, Iowa, the fifth of six children. Her working class Irish Catholic family relocated to southern California by way of western Canada. As a child, "Frannie" was both an emerging artist and a voracious reader. Her father credited her with making perfect reproductions of drawings of English artist Aubrey Beardsley. The caption under her high school yearbook snapshot read, "Frances Kent: devoted to art." When she was eighteen, Frances entered the convent of the Immaculate Heart of Mary, taking the name Sister Mary Corita—or "little heart" in Latin.

Her first teaching assignment was with First Nation children in western Canada. Later, her scholarly community—in particular, her energetic and entrepreneurial mentor, "Maggie"—encouraged Corita to study art. She completed a Bachelor's degree in Art from Immaculate Heart College in 1941 and a Master's degree in Art History from the University of Southern California in 1951. As good fortune would have it, around that time, María Martínez, the widow of an accomplished Mexican muralist, gave Corita an impromptu serigraphy (silkscreen printing) lesson. Corita would later teach silk screening to hundreds of students in a cinderblock studio at the corner of Western and Franklin Avenues in Hollywood. Here, she produced much of her own work in the month of August when school was out, with the help of many friends. Serigraphy, for which Corita is still highly regarded, became her signature medium.

Even while wearing a multi-layered habit—which she did with amazing style for most of her teaching life—Sister Corita couldn't have weighed more than 98 pounds. Nonetheless, she would sweep into the art studio, larger than life, punctuating her teaching with disarming quips. "Life is an opportunity to speak out before all the answers are in," or "The commonplace is not worthless, there is simply lots of it." These were often followed by killer assignments. "By tomorrow, do a hundred drawings of common objects—a chair, a hand, a shadow. Draw with a chopstick and India ink, use your non-dominant hand." No student dared to miss a word, a gesture, a deadline.

When she wasn't masterminding campus-wide happenings, doing chores, teaching, or producing art, Corita read. Suffering from a combination of insatiable curiosity and insomnia, she scanned everything from Gertrude Stein to Martin Luther King, Jr., from the prophets to the Beatles. Many of the quotes she gathered during those sleepless nights later reemerged, transformed into classroom lectures, or art, or both.

The tumultuous 1960s shaped Corita even as she shaped her students to see themselves as artists, world citizens, and people making "acts of

hope."Immaculate Heart College in Hollywood reinvented Catholic cool, attracting poets, inventors, designers, filmmakers, and cultural luminaries to campus. Sister Corita co-taught classes with many inspired teachers, including Charles Eames and his wife Ray, both visionary designers. The Eames showed students their documentary short films on toys, or travel, or soapsuds, sharing. their respect for the significance of the seemingly "insignificant." In 1967, Corita appeared on the cover of *Newsweek* magazine with the headline "The Nun: Going Modern." Many valued her work as a symbol of much-needed ecumenical change. Artist Ben Shahn, however, once referred to Corita as the artist who joyously revolutionized type design, and Corita became known as the "joyous revolutionary." She often used insightful quotes from sources as far flung as science and philosophy to pop music and culture. Her use of free flowing, zoomy word juxtapositions might appear by today's standards to be inspired by computer graphics, even though her work predated the widespread use of the Internet by over three decades. Corita was, simply put, way ahead of her times.

Whatever her notoriety, Corita's enormous inventiveness touched people's hearts and minds as much as she was touched by the pulse of her times. In September 1968, in the midst of social upheaval and personal change, Corita resigned from her teaching position and religious order, and relocated to Boston. Her career rarely faltered. During the next eighteen years she exhibited her prints nationally, she became a plein air watercolorist, and she produced distinctive works of public art. Most famous among these, perhaps, were her "Love" stamp for the United States Postal Service, and a 150-foot rainbow painted on a gas tank near Boston. Corita also designed a billboard campaign based on the affirmation, "We can create life without war," which she considered the most religious thing she ever did. In 1974, Corita began a 12-year-long struggle with cancer. On September 18, 1986, at the age of 68, Corita died gently at a friend's home near Boston. She requested that friends, family, and admirers hold a celebration, not a funeral, in her honor.

Corita often quoted the Balinese who said, "We have no art, we do everything as well as we can." Based on that assumption, Corita developed an art education system in which the classroom and its multiple surroundings are the visual tools for learning and making. Now, with this new edition of *Learning By Heart* readers can rediscover Kent and Steward's uncannily simple methodology: Begin, look, connect & create, work & play, celebrate! The authors' insistence that creativity is based on the close observation of the ordinary and that art cannot be learned except by the heart are primary tools for anyone interested in living, working, and playing creatively.

Barbara Loste, Ph.D.
July, 2008, Spokane, WA

PREFACE

We can all talk, we can all write and if the blocks are removed, we can all draw and paint and make things. Drawing, painting, and making things are natural human activities, but in many they remain in the seed state, as potentials or wishes.

This book contains ways of protecting or nurturing that seed, allowing it to grow into a powerful tree bearing the fruit of hope. Doing and making are acts of hope, and as that hope grows, we stop feeling overwhelmed by the troubles of the world. We remember that we—as individuals and groups—can do something about those troubles.

When I stopped teaching at Immaculate Heart College, I wanted to write a book that would pass on some of the ways of working that students had found useful.

Ten years had gone by and the book wasn't out of my mind. Finally, I asked Jan Steward, a friend and former student, to write it for me. She did.

Now that Immaculate Heart College has closed, it seems more important that some of what transpired between the teachers and the students there be offered to a wider audience.

So if you have ever wished you could draw or paint or make things, if you have hopes of changing something for the better, this book might enable you to do just that.

1

sign for
a wig shop,
Japan

Most of the photographs on these pages are of works done by people who don't call themselves *artists* but who have found the artist and the child who live in them.

BEGIN

canopy for musician, India

wall painting, India

Nancy Jackson's bed, U.S.A.

carved watermelon, Thailand

spoon, Africa

puppets, Burma

NING

plate, Ukraine

straw horse, Mexico

puppet, Italy

*wood carving
Abraham Rothstein
U.S.A.*

fish toy, Laos

balancing toy, China

*the Watts Towers, U.S.A.
angel, Indonesia
mural, U.S.A.
Day of the Dead figures, Mexico*

Creativity belongs to the artist in each of us. To create means to relate. The root meaning of the word art *is to fit together* and we all do this every day. Not all of us are painters but we are all artists. Each time we fit things together we are creating— whether it is to make a loaf of bread, a child, a day.*

As teachers we try to participate in the process of empowering people to be the artists they are. And as artists, we accept responsibility to create—to realize our immense powers to change things, to fit things together in a new way. As artists we work every day. We make our own lives every day; we care for our family every day. It is hard daily work, this creative process. But it is also greater than personal. We are asked to care ·

for others as well—helping them to create their lives as we were helped. Our work is global—we are asked literally to help make the countries of the world fit together in new ways. We begin this making, of course, in our own selves, our homes, our own country—but we can't stop there. To dream about painting and not also to work at it doesn't ever bring about a painting. To dream about creating a new world that is not teetering on the edge of total destruction and not to work at it doesn't make a peaceful world. So it is important that we are creative people working daily on the greater picture as well, bringing to it all our skills of imagination and making. We make this larger picture also with hard daily work, by specific actions. All our creative skills are needed to keep up this tremendous

work. And we work on it so that we and our children may have a world in which to fulfill our reason for being here–which is to create.

There is an energy in the creative process that belongs in the league of those energies which can uplift, unify, and harmonize all of us.

This energy, which we call "making," is the relating of parts to make a new whole. The result might be a painting, a symphony, a building. If the job is done well, the work of art gives us an experience of wholeness called ecstasy–a moment of rising above our feelings of separateness, competition, divisiveness "to a state of exalted delight in which normal understanding is felt to be surpassed" (Webster's).

In a way, the maker (artist) gives us a small taste of that larger art–the new world we are trying to build–a world in which each person, each country, lives in harmonious relationship with each other person and country.

There is a Zen statement, After ecstasy the laundry, which we might reverse to say, After much laundry comes a moment of ecstasy. The smaller ecstasies (arts) keep us nourished so that we have the strength to continue working on the larger art.

For about fifteen years–from the mid fifties through the sixties–a remarkable adventure in education took place in a small Catholic college on a hill in Hollywood. A gifted faculty shone the light of poetry on basic skills and daily living. In the art department, Dr. Aloes Schardt and later Dr. Paul Laporte led their students through other times in classes of art history. Sister Magdalen Mary organized the department, formed one of the outstanding collections of folk art in America, and taught painting, mosaics and serigraphy, and Sister Mary Corita taught the rest of the classes. They taught us how to keep our eyes and minds open and that art is not separate from life. They were (and still are) animating forces in the lives of their students.

Corita's classes were called "Lettering and Layout," "Image Finding," "Drawing," "Art Structure," and various other imposing titles. It didn't matter what names they had–they were classes in Corita. She insisted, coaxed, demanded, and in short, was a tyrant. She taught with the pull of a strong tide. Bit by exhausting bit we were pushed into an awareness of the pulse and beauty of life around us and how to put them together to make our own life song.

We have no art, we do everything as well as we can was the motto of the art department at Immaculate Heart College. It is from the Balinese, a culture whose vocabulary does not include the noun *art*. The guiding philosophy of Balinese life is expressed in active verbs: to dance, to sing, to paint, to play. *Art* is a noun label and neither the Balinese nor Corita believed that one can live a life of labels, a life already defined. To work, play, see, touch, laugh, cry, build, and use it all–even the painful parts, and survive with style: that's what Corita taught. She taught that art is not something apart from life and living. Her nonstop, red-eye-special assignments tore away at preconceptions, exhausted the self-conscious approach to art and led us finally, open and hopeful, in new directions. She asked that we let happen a personal journey down unfamiliar roads–in pursuit of answers which were, in some ways, less important than the trip. She knew we would encounter terrific surprises along the way, and her job was to make us able to experience and relish them. Living the questions was our job; we were never being *artists*.

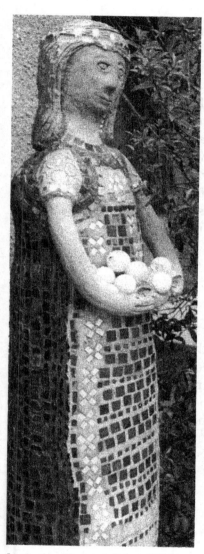

Corita became my teacher, guide, and illuminator. She showed me literally how to see, by increments, a little at a time and then she showed me how to put together the words and music of the life around me. She taught me how to work hard and then keep on working 'til all came round right, and then how to play hard after that, and probably the best thing was when work and play were the same. She taught me not to remember the child I had been but to nourish the child still alive within me.

Corita told me my work was okay and that I was okay and sometimes I was more than okay and so was my work. And then she pushed and shoved and kicked and scolded and bribed me into believing it. She never said an untruth or gave false praise. She always found something good in the worst piece.

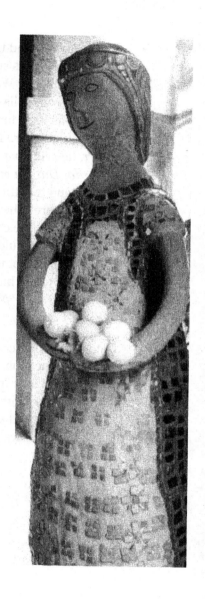

Larger than life mosaic figures, IHC

I know what Corita did for me, and I wanted to know if it were the same for others. I asked the first three people I spoke to about this project, *What happened to you in the art department?* Two said Corita had saved their lives and the third said Corita had given her life.

Neighbors around the corner from us have just added a beautiful deck to their house. I was sure when I saw it that it had been made by some Japanese master. Woodgrains were perfectly matched, joints formed and held–not with nails–but by interlocking pieces of wood. I was surprised when I was introduced to the carpenter, a young man of thirty-two. I asked him where he learned to do such fine work. *I went to Immaculate Heart,* he said, *and was taught by a woman whose teacher had been a student of Corita. Did you ever hear of her?* A few months ago I went for a new pair of glasses and told the young woman who helped me how much I liked her cheerful store. There were serigraphs, children's drawings, banners hanging from the ceiling, and a parrot in a cage with his vocabulary written out so visitors could talk to him and get an appropriate reply. I asked who had put it all together. *I did,* she answered, and I asked her how she knew how to do this. *I had a wonderful art teacher,* she said. *She didn't teach us how to draw or paint so much as she taught us to care. She was a student of Sister Corita.*

Both the carpenter and the woman in the optometrist's shop spoke of how their art education had changed their lives–how what they had learned there spilled over into the rest of the world and changed it too. Neither had known Corita. Both had benefited from her teaching. I realized the process was alive and well after all these years and continued to have the power of those early days. With each generation, new ideas and new materials were added.

If you have ever watched a wave coming to shore, you will have a pretty good idea of how Corita taught and how this book has been made and laid out. A long wave moves toward the shore in one great, continuous, rolling swell. Parts of the swell crest and break before other parts. As the wave advances, the foam outlining the breaking crests spreads and joins the next breaking crest–until finally the whole wave is included.

Now it looks like a continuous white line and soon it will be a flat bed of foam at our feet. The wave is the same wave but it includes many changing elements. It picks up and drops material as it moves along. The wave's approach is broad and inclusive rather than the arcing line of a shooting star, even though it may move very fast.

In Corita's classes, poetry worked in and out with the other arts, theory, techniques, rules, and assignments. This great, broad wave advanced and sometimes engulfed us. I have tried to make the pages of this book the same kind of wave. Each reader will understand and act on the ideas according to his or her own life experience. The mass of material is not meant to overwhelm, but to offer more than enough to work from.

I have used very few paintings or other art works by famous artists in this book. By learning to see the beauty in the world around us, and by looking at many things (not necessarily called art), we can lose our judgmental attitudes about pretty and ugly, good and bad art. We will then be able to find our own visual masters.

We worked within a rigorously imposed set of rules, but the most important rule was that a new set be established each week. We learned to adjust and become flexible.

Corita insisted that her students be totally devoted to the job at hand and gave generous praise for its completion, yet refused to enshrine it. She saw the finished work as a prelude to the next project.

Textbook definitions of art usually have a static quality that contradicts the process Corita taught. Yet in order to share the process, one must at least describe it, if not define it. I sent out a mailing to hundreds of alumni asking, *What was the most terrific thing you learned in the art department?* so that we could share the task of describing the peculiar way of teaching that left us exhilarated and hopeful when, by rights, we should have been exhausted and overwhelmed by the enormous demands placed upon us.

Former Immaculate Heart familiar exercises and ideas as material from my own life. personal life have been art. It was in Bali that I Corita's teaching meant students, following different in his or her own way: that was

College students will see throughout the book as well My professional career and deeply involved in Asian comprehended wholly what to me. Each of her former paths, would write this book one of Corita's gifts. She taught

us a way of working so true and basic that we could extract the essence of that process and apply it to the work before us whatever direction our lives took.

This book is not meant to be a history. Histories are usually written after the fact. The process I want to describe is living and squirming and very difficult to pin down. The process is one of teaching, learning, growing, and doing things to make the world a better place. Whether that world is within you or as great as infinity.

Sister Mag said, *Education is the by-product of the disinterested quest for all that deserves to be sought and loved for its own sake.* To begin this process of

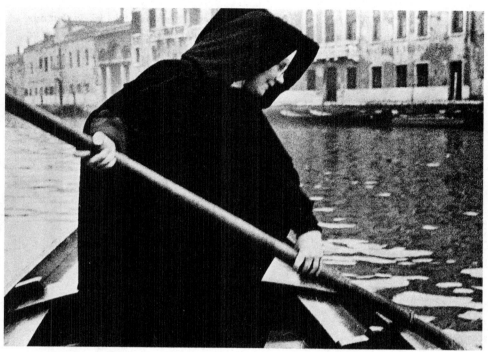

Sister Magdalen Mary in Venice

seeking and loving, we were given tools and exercises. They were, in a way, both progenitors and by-products of our searches. In this book, I have tried to give some of these tools and exercises so that you can go on making your own tools and exercises for your own search.

This book has, thank goodness, turned out much less poetic and beautiful than I had initially hoped. It's meant to be a workbook.

> *The artist is not a special kind of man,*
> *but every man is a special kind of artist.*
> Meister Eckhart

LO●K

We don't really know what already exists in the universe, so we have to be alert to see what we've not seen before. Look at something around you and say about whatever catches your eye,

I don't understand that object now.

We don't understand the fullness of everything, of anything. Things constantly change and we may have seen an object only five minutes ago and thought we knew it—but now it is very different. To be able to adjust to these subtle differences means looking anew with what new materials we have gathered up inside

ourselves—as well as noting what changes have taken place within the object. We need to be aware of what we don't yet know.

Matisse said that to look at something as though you had never seen it requires great courage.

Our eyes, of course, are one of our finest tools, needing constant care. In this chapter there are many ways of caring, of sharpening our tool, keeping it clean, oiling its parts, using it properly, respecting its value. We might also consider the negative results that come from not caring for the tool—it would rust and fall apart,

12

... it is not necessary to the child to awaken to the sense of the strange and humorous by giving a man a luminous nose ... to the child it is sufficiently strange and humorous to have a nose at all.

G. K. Chesterton

ING

becoming useless. We would lose it; we would become blind.

One of the most important parts of growing up is to see ourselves as we really are instead of assuming that we are what our parents and teachers told us we were. Today there is an added complication—another set of parents and teachers telling us who we are and what we should value—the television set. In its finer moments, it can be an enrichment of seeing. But in its lesser moments it is a very sick parent-teacher. It can promote false and trivial values and attitudes to a whole country.

It can show us violence as a solution to our difficulties, charm as the quality desirable in our elected officials. It can present wealth and ease and beauty of body as the qualities that can make an attractive, successful human being. These caricatures of real drama and real people are telling us who we are. In watching the cheaper side of television, we are putting our valuable tool (our eyes) to very destructive uses, and we are not growing up.

Corita

FIND A CHILD

If you have a child of two or three, or can borrow one, let her give you
beginning lessons in looking. It takes just a few minutes. Ask the child to
come from the front of the house to the back and closely observe her small
journey. It will be full of pauses, circling, touching and picking up in order
to smell, shake, taste, rub, and scrape. The child's eyes won't leave
the ground, and every piece of paper, every scrap, every object along the
path will be a new discovery.

It does not matter that this is all familiar territory–the same house, the same
rug and chair. To the child, the journey of this particular day, with its
special light and sound, has never been made before. So the child treats the
situation with the open curiosity and attention that it deserves.

The child is quite right.

LOOKING AT SHADOWS

It takes practice
for us to recover this ability
to see, or before that, the gift
of wanting to see.

For so many years we have
been learning to judge and dismiss
—*I know what that thing is—I've
seen it a hundred times*—and we've
lost the complex realities, laws,
and details that surround us.

Try looking the way the child looks
—as if always for the first time—and
you will, I promise, feel wider
awake than since you yourself
wound your own way
from that back of the house
to the front.

Try it.

Do it.

Begin by looking
at the shadows
in your room.
After about five minutes
you will probably think
you've seen everything.
But then after fifteen
or maybe twenty-seven
or fifty-eight minutes,
it's like an explosion
and you see
thousands of things
you never knew
were there.
And you know
you could go on looking
forever
and never see it all–
the rich texture
of that same old wall,
the shadowy angles
of the window ledge–
and everything
will always be new.

You will make new
connections and
relationships,
and become aware
of subtle shading
and implications.
No amount of reading
about looking
can do it for you.
Do it.

Look at those shadows.

Art does not come from thinking but from responding.

Corita

THE SENSE DIARY

The following exercises in looking can be the beginning of a sense diary–a most valuable record of sources and resources. Almost any sort of notebook will do if the paper is appropriate for drawing and painting and is strong enough to take plenty of handling. There are good, ready-made books available, or you can make your own. Instructions for book making will be found in the chapter "Tools and Techniques."

A sense diary is a tool that enables us to become aware of and retain details often lost or imperfectly remembered. You will see the interrelatedness of things and how specifics from one subject may apply to the next. In it you will keep descriptions of things seen, heard, or read. These descriptions may be your own words, or if you find better ones said by someone else, use them. The sense diary is your expandable vault in which to store words, ideas, and images.

In addition to assignments, put in your sense diary:

Favorite poems, prose, and sayings. Words that mean something to you, that make you feel something.

Lists of musical compositions, composers, books to be read or books you have read, plays and films, seen or to be seen.

Factual descriptions of subjects of interest found in encyclopedias or other reference books (which often give new shades of meaning to the familiar and make surprising connections); new words; marketplace words and descriptions; single words that have a ring, that wake you, that make you want to do something, that are funny, mysterious, or strange to speak; words that when you look at them for a very long time seem to be foreign, misspelled, or nonsense.

assignment

For one week look at the shadows in one corner of the room in which you are sitting. Sit in the same place every day for fifteen minutes and write everything you see about those shadows. Record their changes in your sense diary–changes in color, size, and shape.

Then take something that doesn't change–a soda bottle is fine. Look at the top third of that bottle every day for fifteen minutes and record all you see there. Do this the same week you are looking at shadows.

This kind of looking requires shutting out everything else, slowing down, and being very patient.

assignment

Look at a tree and its shape. Look at the part the leaves
play in making the shape you see and look at the part
the trunk and branches play in making the structure
you see. Look for patterns made where the foliage is
dense or light. Look for dark and light and other color
changes that come about on the leaves, which are really all
the same color but change with the reflections of light.

Look at a tree for one hour in the week you are seeing
shadows. Write every specific thing you see about that
tree. Make a list of other things that you think are
related in structure to a tree: an umbrella, a lamp, a broom.

When you get past making labels for things,
it is possible to combine and transform elements into new things.
Look at things until their import, identity, name,
use, and description have dissolved.

NOTHING IS THE SAME

When we give names to things, we often assume that everything that goes by that name is alike.

assignment

Take something in nature—two dandelions—and look at them for five minutes, listing how they are different from each other. Take two leaves from the same tree and do the same thing. Take two peas from the same pod and do the same thing. Nothing is the same. No thing is the same. Everything is itself and one of a kind.

After doing this for a week, look back at these pairs of things again and make a new list. You will find more differences because you have been exercising your powers of observation.

Genius is looking at things in an unhabitual way.

Work in areas where you are unsure, in places you've not been before.

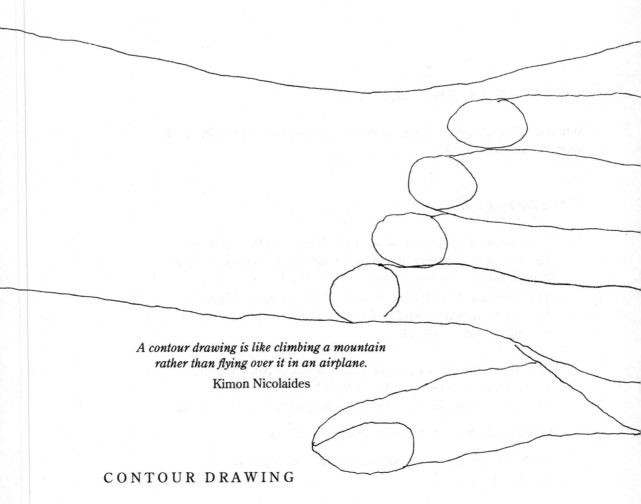

*A contour drawing is like climbing a mountain
rather than flying over it in an airplane.*

Kimon Nicolaides

CONTOUR DRAWING

Contour drawings are drawings made while you look intently at your model or at the object to be drawn and not at your paper or at the drawing you are making. Contour drawing is a way of looking as much as it is a way of drawing.

One of the great values of contour drawing is that it makes it very difficult to be judgmental about your work. Contour drawing helps you see things and let your intuition make choices.

This kind of drawing must be done very slowly.

Drawings done in this way are different from drawings done with the interruptions of back-and-forth eye movements, and the kind of visual hairsplitting that comes from the criticism of a work in progress. Creating and analyzing are different processes and can't be done at the same time. Contour drawings often have a vitality lacking in works that are too carefully considered or fussed over.

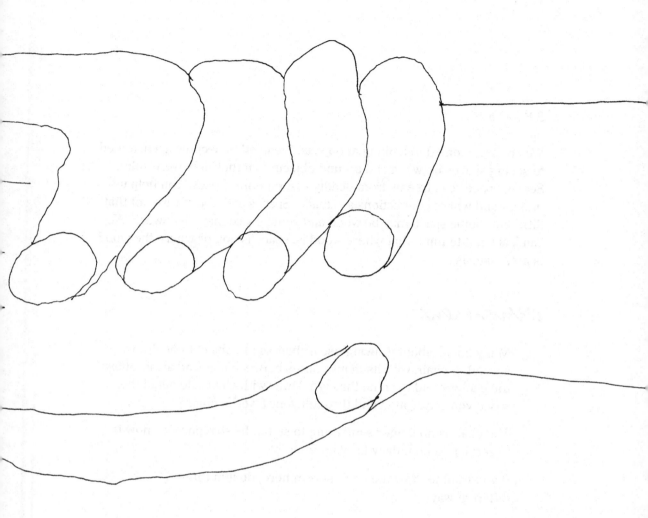

assignment

See your shoe. Put the point of your pen or pencil (or other tool) on the paper in front of you and determine where that point is on your shoe. Believe that the pencil will faithfully follow the outlines and details of the shoe, as the eye does. The eye must move very slowly, at the same speed as the pencil–simultaneously. Be careful not to let one or the other get ahead. Do it three different ways:

Start at the top of the object and draw down to its base.

Start at the bottom and go up.

Start at one corner and draw to the opposite.

Don't worry about skill. The drawing will have life.

SPACES

We are accustomed to looking at objects. We need to become accustomed to seeing spaces between and around objects as if they, too, were solid. Seeing spaces can free us from deadly assumptions. Spaces can help us understand where connections are made. Spaces and objects are not that different—some space may be wood and some space may be flowers. We can learn not to think that where wood is, space is not, or where the wood is not, space is.

assignment

Many books about drawing use a chair as the object to be drawn around. A chair, with its many spaces between legs and arms, allows the background to come through. Draw with elaborate detail the space you see around and through your favorite chair.

The chair is no longer something to sit on. Its sole purpose now is to serve as a boundary for your interest.

If you want to draw the chair shown here, do it in three different ways:

Draw the spaces.

Do a contour drawing.

Draw only the ornamentation, not the outline.

Make up three more ways to draw this chair.

Art does not reproduce the visible,
but makes visible that which is not easily seen.
Kimon Nikolaides

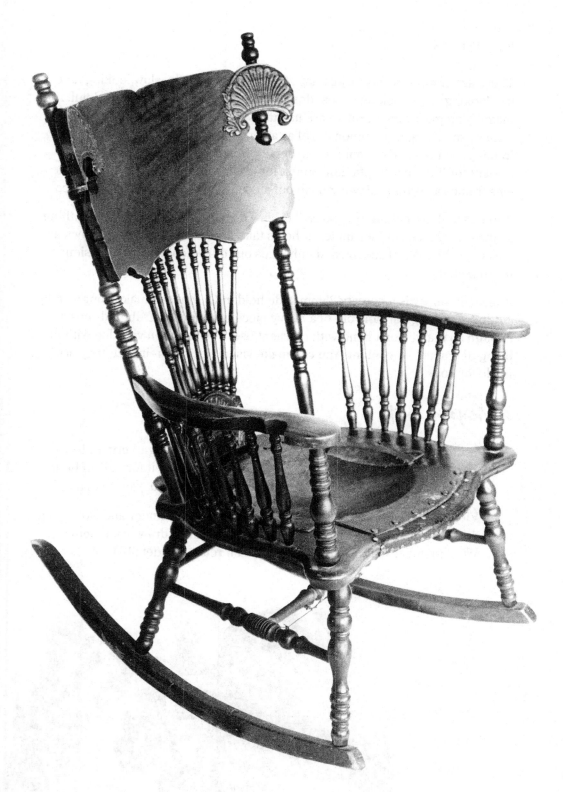

FINDERS

There are, for our purposes just now, two ways of looking–slow looking and fast looking. Slow looking is best done alone. Special equipment is helpful. A magnifying glass and a camera are useful tools. Charles Eames said that a camera should be as common a tool as a pencil, not just for recording, but for framing pictures and examining the details. You needn't have film in the camera for it to be a helpful implement for learning how to look and see. The lens frames a section, allowing us to put all our attention on that special area.

Another tool for looking is a *finder.* This is a device which does the same thing as the camera lens or viewfinder. It helps take things out of context, allows us to see for the sake of seeing, and enhances our quick-looking and decision-making skills.

An instant finder is an empty 35mm slide holder. Or you can make your own by cutting a rectangular hole out of a heavy piece of paper or cardboard–heavy enough so that it won't bend with constant use. You can then view life without being distracted by content. You can make visual decisions–in fact, they are made for you.

assignment

Take your finder to the market, the theater, park, any gathering place where there is a lot to see. Look at the world through it for half an hour. The shapes you see there might become paintings you want to make.

View the facade of the nearest building through the finder and isolate ten details to draw on the spot. (It is very dangerous to draw from memory. We remember inaccurately and rarely can retain the details.)

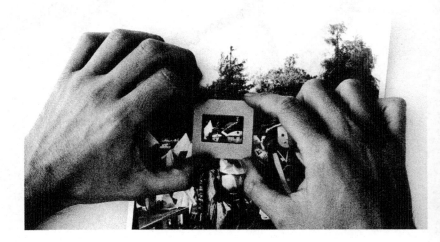

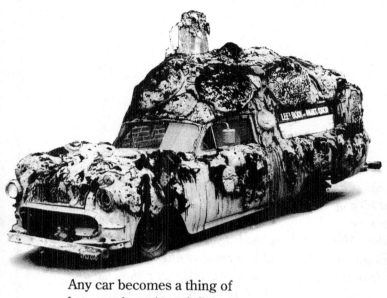

Any car becomes a thing of
beauty when viewed through
a finder.

Use your finder on your car.

There are mornings when the sun pours in and the sky is that kind of blue you know you've never seen before. And the quality of the white clouds floating and the geraniums blooming indoors and the floor and carpets and all the colors and shapes are new too. These moments are very intense because you can hardly believe that this beauty exists every day when you are going faster or you have your back turned to it.

And it's these moments that one feels yes, the same blood runs in us all and these things are really me too. All these things are, as Alan Watts said, extensions of myself. *And I think how beautiful, how really great I am. I am this tree and I am that flower and I am not separate from them.*

There is an exercise I've learned lately, and that is to be quiet and look at an object or space directly ahead of you. Keep a soft focus and also allow your attention to reach past your peripheral vision, left and right. In addition, place your attention on top of or above your head. All of these directions—front, right, left, above—being looked at with a kind of diffuseness. You try to have a clear moment when you are empty and open to things around you. You see them new—your vision is cleansed and you can make contact with what is really there, uncluttered by old thoughts and prejudices. Always be ready to see what you haven't seen before. It's a kind of looking where you don't know what you're looking for.

PICTURES ARE FORMED
BY THE IMAGES AROUND US

Since we humans first made paintings, we have used nature and the world around us as a source. Paintings of exceptional beauty discovered by playing children in 1941, in cave sites in France, give insight into the lives of hunter-artists who lived between 15,000 and 10,000 B.C. The acute powers of observation are apparent in the anatomically correct depictions of various animals; yet they are also imbued with the personal visions of the artists–in the qualities of grace, cunning, ferocity and greed–which were, to the artists, the essence of those animals.

Thousands of years later, in the fifth century B.C., Herodotus described what he saw lining the processional way into Babylon. In mosaic form, the naturalistic qualities of lions were accentuated by carefully articulated muscles, noble bearing, and snarling muzzles which conveyed their exalted nature–not merely as animals, but as creatures sacred to the goddess Ishtar.

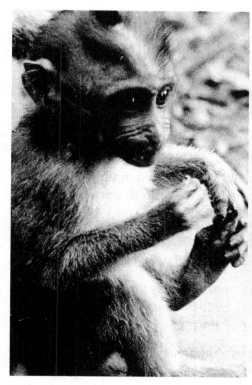

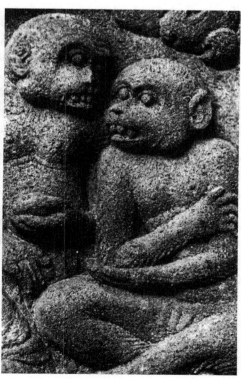

monkeys in Bali

relief from Borabadur, Java

Show me an angel and I'll paint one, said Courbet (1819-1877), whose unconventionally realistic work was rejected by the art establishment as crude, harshly materialistic, and too large—and by a public whose sense of aesthetics called it ugly.

Yet the medieval painter Giotto did paint angels and did paint what he saw. His angels are depicted as humans—often young, beautiful, and (to enhance the idea of flying) without feet. Their wings are the wings of closely observed birds.

The Impressionists Manet, Seurat, and Cézanne sometimes painted picnics and food, the things of everyday life. With fruit, bottles of wine, or landscapes as his source, Cézanne used his powers of visual concentration to transform their properties of lines and planes into what Helen Gardner in *Art Through the Ages* calls *an architecture of color.* With familiar objects as his source, he selectively chose those details he wished to investigate.

Georgia O'Keeffe drew and painted the things she saw in the desert around her through her personal vision. Often, they are simply beautiful shapes and colors, and the viewer may not be able to identify the original source.

Also in contemporary times, Andy Warhol used the familiar objects of a mass-production society to present rhythm and brilliant color in his large-scale reproductions of Campbell's Soup cans stacked upon each other.

History has shown that virtually anything from everyday life can be used as a source for our image making. Campbell's Soup is a long way from the caves of Lascaux, but we still are painting what we see.

Look at today's landscape—billboards, freeway systems, electric power plants (most beautiful at night), and so forth—to see how they can become art.

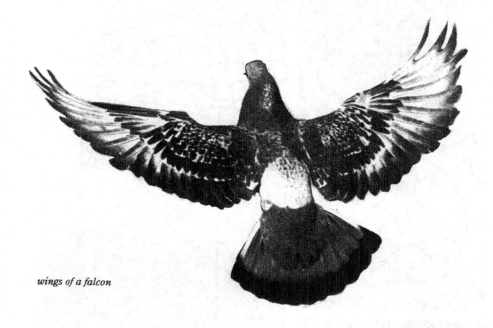

wings of a falcon

painting using Giotto as a source

One purpose of art is to alert people to things they might have missed.

Corita

DEVELOPING OUR SEEING MUSCLES

Artists are people who have developed their seeing muscles in much the same way as weight-lifters develop their lifting muscles–by constant, disciplined use.

There are many styles and ways of seeing. The thesaurus mentions *discern, perceive,* and *behold* as elements of seeing. To really see implies one is making an appraisal of many elements. When we finally comprehend and understand a situation our response is often, *I see!* Connections are made, the truth revealed.

Looking is not the same as seeing. The Webster's definition of *looking* is, in part, *to receive an ocular impression. I looked at the morning paper* implies a casual perusal, without gathering or connecting. But seeing begins with looking. Look hard, look long, look soft–with your peripheral vision. Look at things upside down, through finders, examining details and seeing them as complete pictures. Looking is the beginning of seeing.

assignment

For ten minutes a day look at a plant that is native to your area. Write about the plant for fifteen minutes every day, describing visual details, as well as the feel, the fragrance, and the sound made when the wind blows through it. Do ten drawings each day of the leaves or other foliage and ten drawings each day of the whole plant. This is a wonderful exercise to combat the habitual.

assignment

Use your finder on the photograph above.

Do ten contour drawings of the pictures you have framed.

Each drawing should fill a page the size of the photograph.

Use your finder again, this time on the ten drawings you have just made.

Draw ten new full-size pictures, one from each of the original ten.

Use your finder to frame the new works, which you will now draw.

PRETEND YOU ARE A MICROSCOPE

assignment

Look at the cracks in the asphalt with your finder for five minutes each day for a week. Make a series of drawings from each found asphalt picture. Shadows in the cracks change, lengthen, become upright, pale out, and disappear according to the light and the position of the sun. View the asphalt at different times each day, but look at the same section of asphalt. Concrete will do.

MAKE A MOVIE WITH YOUR EYES

The kind of looking described so far—noting details to be written in the sense diary, contour drawing, and looking with a finder—is a kind of slow-looking, an appraisal of details, and best done alone.

Fast-looking can be done with lots of people around, and it builds energy. It is the kind of looking done from the windows of moving trains, at parades, or in crowded museums just before closing time. Images are speedily processed and stored in the memory banks for future use.

Fast-looking and slow-looking are different ways to view the same thing. Your pictures will be different because the methods of viewing are different.

assignment

This is an exercise to lose content and context.

Cut one hundred ten cards. Cards, for our purposes, are any rectangular section (two by three inches is a good size) cut from a magazine. As is the nature of a set of cards, they should be the same size.

One way to get quick cards is to use a two-by-three-inch finder as a template. Place the finder on top of a stack of magazines and cut through as many pages as possible with a sharp X-acto knife. Another good method is to cut two-inch strips from a stack of magazine pages and then cut the strips into three-inch lengths. A paper cutter makes this job easier.

To keep yourself from making judgments about the pictures, do this cutting quickly.

Make two piles. One you like and one you like less. If content is more important than form, discard the picture. (A photo of a child is an example of material chosen for content rather than form.)

Look at the shapes in the pictures you have cut. Make a list of the uses you could find for these pictures as layouts. Which of these pictures would be good design layouts for:

a bulletin board	a buffet table
a birthday cake	a letter
a poster	a photo album
a garden	a record jacket

Always choose for looks. Don't be concerned about particular designs for specific purposes. Limitations of media and purpose inherent in each task will form your structure, and a faithfulness to that structure will make the design appropriate to the project.

One could describe design as a plan for arranging elements
to accomplish a particular purpose.
Charles Eames

READ WHAT PEOPLE SEE

In your reading pay special attention to
how people see and describe things.

I say that the blueness we see in the
atmosphere is not intrinsic color, but is
caused by warm vapor evaporated in
minute and insensible atoms on which
the solar rays fall, rendering them
luminous against the infinite darkness
of the fiery sphere which lies beyond
and includes it. And this may be seen
as I saw it, by anyone going up
Monboso [Monte Rosa, a peak in the
Alps which divides France from Italy].
Again as an illustration of the color of
the atmosphere I will mention the
smoke of old and dry wood, which, as it
comes out of a chimney, appears to
turn very blue when seen between the
eye and the dark distances. But as it
rises and comes between the eye and
the bright atmosphere, it at once shows
an ashy gray color; and this happens
because it no longer has darkness
behind it, but this bright and luminous
space. If the smoke is from young,
green wood, it will not appear blue
because, not being transparent and
being full of superabundant moisture, it
has the effect of condensed clouds
which take distinct lights and shadows
like a solid body.

Leonardo da Vinci

38

SOUR

Charles Eames

SOURCE: from the Latin surgere, "to spring up, to lift." The beginning of a stream of water or the like; a spring, a fountain. The origin; the first or ultimate cause. A person, book, or document that supplies information. A source is a point of departure.

I had already finished school when I met my real teacher, Charles Eames. He was not an art teacher; he was an artist who taught— taught by words, films, exhibits, buildings, classes, visits, phone conversations, and furniture. He dropped out or was dropped out of college before graduation. When he was asked for credentials for a teaching job, he got his friend Saul Steinberg to draw a diploma that had lots of writing but no words, complete with seal and red ribbons. Charles had great style in all he did.

For this country's first cultural exchange with Russia he made a seven-screen film—each screen showing still and moving images simultaneously—that explained the American way of life to the Russians. Seven screens, he said, to present more fully the complexities of our problems (and delights) so that all might benefit from our experience without having to repeat our mistakes. After that, one screen was never enough.

When he talked, he often made long pauses in his sentences. It was as if he was stopping midway because new relationships and connections had come in since he had started the sentence and he needed to form the next phrase to include those new ideas. He used words that were simple and almost absolutely appropriate.

Charles said that the first step in designing a lamp (or anything) was not to ask how it should look—but whether it should even be. He always started fresh at the beginning. He showed us how to develop principles rather than follow formulas.

When I taught, I could show any one of several of his films to introduce any new project to my students. I have shown and seen some of his films literally hundreds of times. Like Spring, they never bore. The first film Charles ever gave our school was Parade (seven minutes). We showed it that morning seven times in a row, stopping only long enough to rewind. He spoke always with the light touch evident in Parade, in simple words; but his lightest touch was somehow principle. His films will go on teaching forever.

From Eames or from any of his works we learn to drop outworn distinctions and separations and to see new relationships—to see that there is no line where art stops and life begins. He talked a lot about connections.

Of his teachings I can hardly distinguish between what he actually said and did from what he taught me to say and do myself. His teaching is still living in me and I am still learning from that life in me, as well as from students and friends and every single contact with people and things. He taught me that too.

At Berkeley he and his wife, Ray, taught an introductory class to all architecture students. Overhearing one of the students make a derogatory remark about Renaissance art, he constructed an assignment. Each student was to choose a limited time in one culture and find out everything he could about that time and place. What people wore, what eating utensils they used—everything. Digging deep this way opened up the reasons and atmosphere that determined the shape of the things that were made.

I borrowed this assignment for an interior design class. I began the class by asking each student to say what "style" she wanted her home to be done in. Then came the Eames

the Eames office

Ray Eames

assignment. I will never forget the reaction of the student who had chosen "colonial." She was giving her report with great enthusiasm—describing the look and contents of a real colonial home—when she came to the point of describing the guns hung above the fireplace. It dawned on her that the lived life had a lot to do with how her home looked. I can still see the look coming over her face as she spat out, Oh, I hate you! She had convinced herself against her early choice. She had taught herself a lot. A good assignment can make the student do just that.

Some good sources come naturally out of what the teacher is filling herself with and become part of the bombardment of materials that are a regular part of giving a new assignment or starting a class. Books like Spinster by Sylvia Ashton Warner, which is a splendid novel that describes an inspired kind of teaching, can be quoted from or assigned. Magical Child by Joseph Chilton Pearce, with its plan of how to grow up well, is another excellent source. Enthusiasms of the teacher flow into the class—a sharing takes place and rich ideas are sparked. We are each other's sources.

Corita

a wall in the Eames office

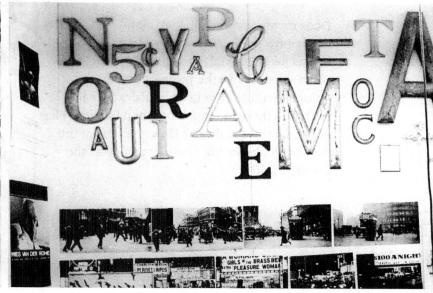

EVERYTHING IS A SOURCE

A film by Allen Downes of the University of Minnesota shows us the beauty
to be found along any city street–in the shapes and reflections of windows,
the shadow of a post, cracks in the concrete. The Eames film *Blacktop*
reveals the splendor of a schoolyard as it is being washed down with
soapy water. In these films and others like them, we are made aware
of the nameless wonder existing in the most usual circumstances.
We needn't search for a source to start our work; sources are all
around us.

There are two objects just to my left on the table where I am typing.
One is a purple plastic ink bottle with black drips and a smudged, dirty,
orange, black, and white label. The other is a photograph of a bronze
statue of Lord Shiva. He is dancing, poised on one foot, under which
lies the dying dwarf of ignorance, whose face is purified by a smile of
liberation. Either could be a source for a drawing. The content of the
object will not determine the success of my work.

The Shiva is a beautiful old piece, made
in the time of the Chola kings in South
India. It has already been done so well.
Even if I did a contour drawing–one
without trying to copy the photo–
even if I worked from enlarged
details of the contour drawing,
I might ask too many questions.

Does my drawing really look like
Lord Shiva or like the statue of him?
Is it as lively, as wild, as strong? Does
Shiva's drum have the proper number of
strings to tighten the head in order to make
it ring? Is there too much pain and too little bliss
on the face of the dwarf? How can I make the
drawing look like the photo or as fine as the
bronze itself?

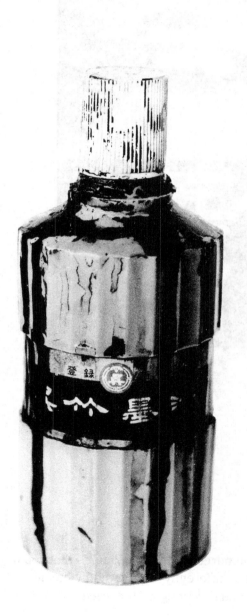

I love the stories of how Lord Shiva danced the world into being and will dance it out again. Can I separate this fondness for the story from the job at hand, which is to make a drawing?

On the other hand–take a look at the ink bottle. I bought it because it was cheaper than the other bottles that were on sale. I have never seen it as a source for anything but black ink–a filler of pens. The form is not familiar and beloved, as is that of Lord Shiva. I've never anticipated its shape or focused on its curves. I don't know legends about grimy ink bottles. Where the cap screws on, there is a dry and shiny crust from which the drips of once-wet ink have made their way through accumulated dust on down the purple sides, over the orange stripes, disappearing in the type of the brand name. The name is done in calligraphy–white on a black background. Where the random spills intersect the letters, new shapes are made of the familiar alphabet. Finally the drips move over the bottom orange border onto the purple plastic. The ink must have once flowed onto the table. Now it has dried and stops at the bottom of the bottle, getting thicker where it dried in pools, held back a bit where the lip of the bottle contained the flow.

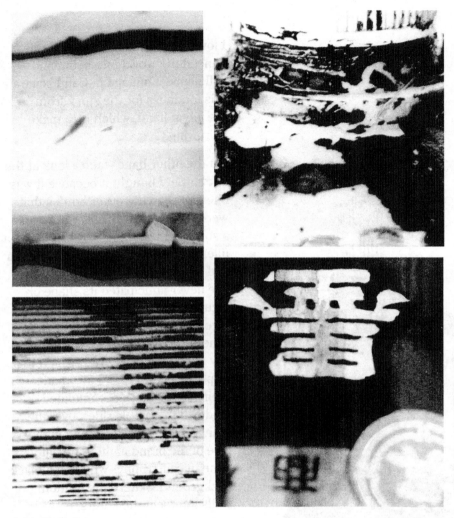

ink bottle findings

I move a finder over the bottle and see hundreds of framed pictures that could become drawings. Light hits each surface differently–swallowed by the dull plastic, making the coated paper bright and reflecting off the dried ink.

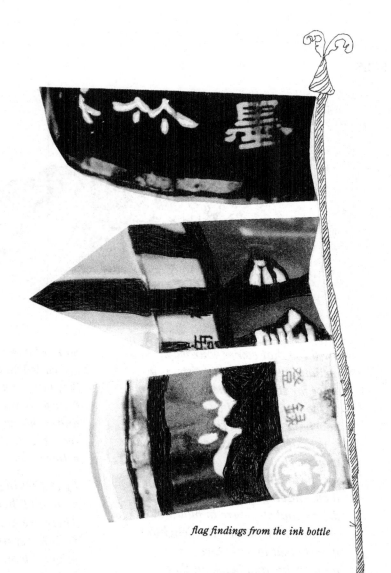

flag findings from the ink bottle

Working from a source is not the same thing as copying. The work is yours only–drawn from your experience and colored by your perceptions. If I choose to draw Lord Shiva, the drawing could be just as fresh and successful as one done from the ink bottle as long as I am able to work at drawing and not at esoteric iconography or familiar shapes. Either object is a source. The source frees us to depart from something rather than from nothing or everything. We do not seek to duplicate the source, but to use it as reference. It relieves us of thinking we have to make something new or great (a scary idea). We will make something new when we work at the source with our mind and leave our hands and pen (stick, chopstick, pencil, etc.) free to get on with the job of drawing (painting, building, etc.).

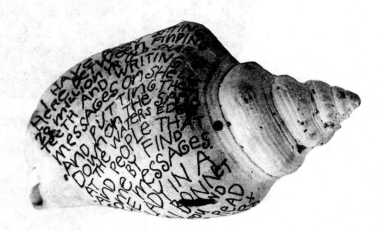

Anything that comes your way, including the work of artists, is a place for starting. I began some time ago to be fascinated by shells and by now have a modest collection which is very delightful for me to look at… to marvel over little creatures spending all that time making them—having the brilliant sense of design and structure to pull that off—and then having the delightful detachment to walk away into another life and leave all that beauty behind.

Before I began making my last series of serigraphs, the thought occurred to me that it might be fun to take photographs of shells and see how they would look flat and if they would work into designs for prints. So I did that and had my prints made and enlarged and worked at them with a finder, until I found the look I wanted each print to have.

So most of my prints from that year are called "shell writings," though they have gone through a kind of transformation, mostly by selection and a change of scale. People don't recognize them as shells and hardly believe it when they are told.

I gather things up first because I like them and then they become sources. There are dry moments when I feel no inner spring at all and then I might flip through books—art books or history books or whatever—to be inspired by something I see that might get me started in a whole new direction. Lately I've thought that many of my pictures have cloud shapes that are like the clouds I have time to watch these days. I wonder if I see clouds that way because my pictures are like that or if the clouds got inside me and took form in the pictures.

Corita

*our original nature
is that of the enlightened
Buddha and we have
just forgotten it*

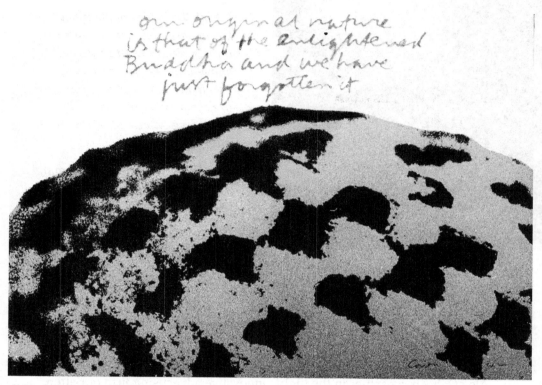

shell painting serigraph by Corita

assignment

Make five contour drawings using as a source a drawing (or painting or photo) by someone else.

Make one contour drawing from each of the five previous drawings.

Make five more drawings from the second set of drawings.

Compare the last set with the original source. Each will have its own life and individuality. The original source was your point of departure.

I think that much of the input that has always come into me has come through relationships with people I know—and perhaps sources are people I'm not even aware of. You are constantly being fed with— depending on how open you are— many new ideas.

New ideas are bursting all around and all this comes into you and is changed by you.

Corita

BRAINSTORMING

We are each other's sources.

Alex Osborn, a partner in the highly innovative advertising firm of Batten, Barton, Durstine and Osborn, developed the technique he called brainstorming as a tool to expand one's creative vision. This simple process involves taking note of every idea that surfaces without placing value on it. Group application of the process is most productive because we make available each other's ideas and memory banks. Solo brainstorming is also very helpful in accessing and retrieving material we may have stored. Solo brainstorming is done by making very long lists of your ideas as they occur. Rules for brainstorming, whether alone or in groups, are the same.

The first step in any successful session is choosing the problem to be investigated. Whether the problem is broad or specific, it must be stated with clarity. If you are working alone, write the question/problem/goal in large letters at the top of your page. In a group it is helpful to have the title written on a blackboard or on a large piece of paper for everyone to see. Following are some basic rules which must be observed in order to assure the success of your brainstorming session:

Record all ideas as they emerge. One person in the group should be appointed to write each idea on the blackboard or a piece of paper. If you are alone, write down every single thought as it comes to mind.

Suspend all critical judgment until the end of the session. Idea production is ten times greater when imagination isn't restricted by judicial attitudes. By deferring our critical decisions, we keep ideas flowing and come up with many more alternatives from which we can choose later.

Quantity is most important. The goal is to get the greatest number of ideas. The more ideas, the greater is the likelihood of success. It can be beneficial to set a time limit for response so the process moves along without getting hung up with analysis or discussion. Set a goal of how many ideas you want to come up with. Make the number so large (100 or more) that you will have to stretch to achieve your goal. Don't worry that participants will be inhibited by this. The process is so exciting that once it's started, a group will most likely exceed the stated goal, impossible as it may have seemed at the beginning of the session.

Use and build on the ideas of others. Brainstorming gives us this freedom. Combine, add to, manipulate all the ideas which have been written down for all to see. Two heads (or more) really are better than one. (In science, it is a recognized and accepted practice that people build on the work of others. Artists and musicians throughout history have borrowed and built on each other's works as well as helped themselves to the rich store of folk art and music.)

T. S. Eliot says that a minor poet borrows, a great poet steals. Borrowing implies that the source really keeps possession. Stealing implies that the source has become the property of the thief–that she has made it into something her own.

assignment

The making of lists is a most useful device for brainstorming–whether alone or in groups. Don't censor yourself; accept all ideas, whether or not they seem relevant or repetitious. You will delve more deeply and freely and the results will be a richer and broader spectrum of ideas. Make a list of 100 things about celebration. Relate the concept of celebration to the senses. What colors make you feel good? What tastes, scents, and music or other sounds lift your spirits? Whom do you know that celebrates with style? Look at celebrations in other cultures. List ways to perform an habitual task in a new way.

THE PROBLEM AS SOURCE

After you have retrieved the most relevant material from the celebration brainstorming list, the form and substance of the event becomes apparent. Jobs will be defined by the special circumstances of your party. One of the definitions of source is *the origin, the ultimate cause.* In that sense, the problem becomes the source. Ideas and themes from your list will provide the material for your project.

P R O B L E M: To make 250 invitations to your celebration.

Requirements (physical):

Will it go in an envelope?

A self-mailer? (The paper must be heavy enough to withstand handling.)

What are postal regulations for size and weight?

The above physical requirements will determine the kind and size of paper, as will the medium used for reproduction.

Information: Name, day and time, place, description of event, details for participation.

Message: Message is not the same thing as information. Message means, in this case, feelings–about the occasion for celebration. A book of poetry, the work of any writer you admire, words of a favorite person–all can be sources for the message.

Medium: For this problem let's choose serigraphy (silk screen) as the medium most suited to meet the reproduction requirement. You can make as many copies as you need and more later if you leave out someone. What are the limitations and benefits of this technique?

Since you are dealing with ink squeezed through a piece of silk, the process is not the same as painting directly on a piece of paper. You work in the negative. The glue or paper–whatever you apply to the silk as a mask–will keep the ink from coming through. What appears in the final print as color on the paper is the part of the screen you've left unmasked. Areas you have masked don't print.

You can apply flat, opaque colors or transparent overlays. You can use as many colors as you want though each color needs a new image worked on the screen. You can't (easily) achieve graduated shading, texture, or other painterly effects. You can print on cloth or paper. The surface needs to be smooth to achieve a sharp image. Rough-textured cloth could damage the silk screen. You can print on colored paper or cloth because the ink is opaque. You do not see the work growing in the same way as with a painting. You do see a color separation process with the work emerging a color at a time.

Corita making a serigraph

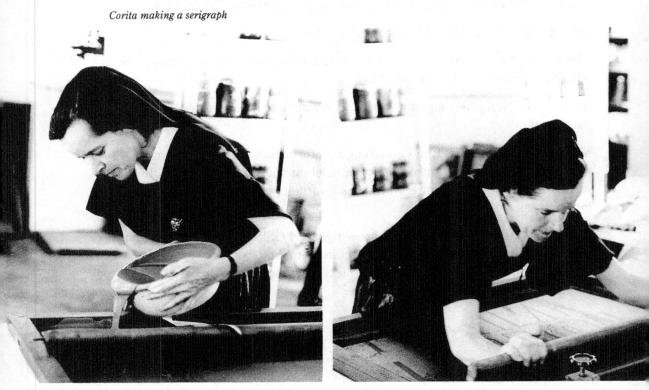

The serigraphy process will impose its own disciplines and in that way acts as both source and structure. There are many books available with detailed instructions on serigraphy–from how to make your own screen to techniques for printing. Keep it simple. Make things easy for yourself and use the least complicated, most readily available techniques and materials.

You do need a visual source for your layout. Don't worry if the source is relevant to the particular project. It is there primarily as a map and to keep you from getting too cerebral or art-conscious.

From the few requirements we have listed, we already have information that will help determine what our work will be. We know the maximum size and weight of the paper; that it will be necessary to work in the negative; that color is not applied directly, but pressed through the silk; that flat, opaque colors with transparent overlays are natural to the screening process. This information was generated by the need to solve a problem–the problem as source.

Taking the ink bottle or shells out of context is one way to find a source. Here is an exercise to take things out of context.

assignment

Look at a magazine in many ways—one way at a time—and write three lines about each point of view.

sociologically

historically

anthropologically

as a parable

meditatively

as a directory

as a work of art

as a fairy tale

as a revolutionary treatise

as humor

as poetry

as layout and design

as lettering

as political indoctrination

as an instruction book

Remember that sources are starting points. When looking for sources for a specific project, don't get too fussy about what is appropriate. Include everything. Sources that might not fit one job may be just right for the next.

assignment

The next time you go to the market take a notebook and write down fifty things about the trip–on the way, there, in the parking lot, coming home.

List ten projects for which sources could be found at the market, not necessarily related to the buying and selling of food.

Make three- or four-line poems from the promises on the food labels.

*Love life
everything–
pale lights
markets medley
of green lettuce,
red cherries,
golden grapes, and
purple eggplants–
all so extraordinary!
Incredible!
You get excited,
you talk to people
and people talk
to you,
you touch
and they touch you.
All this is magical,
like some
endless
celebration.*

Eugene Ionesco

Charles Eames tells about his way of working. The project was a design competition for a new building at the Smithsonian Institution.

We looked at the program and divided it into the essential elements, which turned out to be thirty odd. And we proceeded methodically to make one hundred studies of each element. At the end of the hundred studies we tried to get the solution for that element that suited the thing best, and then set that up as a standard below which we would not fall in the final scheme. Then we proceeded to break down all logical combinations of these elements, trying to not erode the quality that we had gained in the best of the hundred single elements; and then we took those elements and began to search for the logical combinations of combinations, and several of such stages before we even began to consider a plan. And at that point, when we felt we'd gone far enough to consider a plan, worked out study after study and on into the other aspects of the detail and the presentation.

It went on, it was sort of a brutal thing, and at the end of this period, it was a two stage competition and sure enough we were in the second stage. Now you have to start; what do you do? We reorganized all elements, but this time, with a little bit more experience, chose the elements in a different way and proceeded: we made one hundred studies of every element... And went right on down the procedure. And at the end of that time, before the second competition drawings went in, we really wept, it looked so idiotically simple we thought we'd blown the whole bit. And won the competition. This is the secret and you can apply it.

SALUTE YOUR SOURCE

Often we may not realize we are building on the ideas of others but when we do know it, it is good to take responsibility and say thank you for the use of the material. Acknowledge that this work has gotten into you and been changed by you and has changed you. When you can, salute your source, otherwise, without heart or conscience, the work might become plagiarism.

reception room in the Eames office with a backdrop painting used by photographers in India

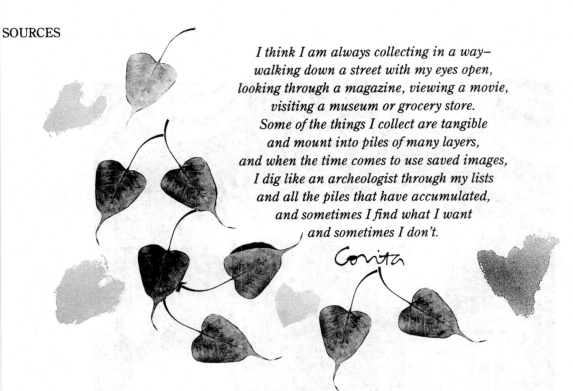

I think I am always collecting in a way–
walking down a street with my eyes open,
looking through a magazine, viewing a movie,
visiting a museum or grocery store.
Some of the things I collect are tangible
and mount into piles of many layers,
and when the time comes to use saved images,
I dig like an archeologist through my lists
and all the piles that have accumulated,
and sometimes I find what I want
and sometimes I don't.

Corita

Corita told us how misunderstanding can be a source.

The actual beginning of all the parades and all the
festivals we had at Immaculate Heart–Mary's Day and
all the rest–was a photograph I clipped from Life
magazine. The photo showed several men holding TV
antennae of the future. At first glance I thought they
were carrying banners of unusual and beautiful shapes.
Even after reading the caption under the picture, my
mind kept mulling over the idea that these would be
better banners than I had always seen. In this case the
source generated the form, the idea for a project. This
continued through the backdoor of a mistake–to the
study of banners, to the study and concept of celebration.
. . . Other sources for banners came afterwards from
such things as children's drawings, signs in used car
lots, customs and celebrations from other countries,
*ideas from films–*India, Parade, Color of the Day–
embroidery and enrichment on anything; photographs
of things seemingly not related to a banner–chairs,
airplanes, paintings.

Never think of a source as being static. Look at changes in the source itself.

assignment

Look at a dandelion as it first begins to push up in your garden.
Make a drawing.

Wait a few days and look at the dandelion as it begins to make a bud.
Make another drawing.

Wait a few more days and draw it in full bloom.

Wait a few more days and draw it when it begins to wilt.

When it develops its downy crown, draw it again.

The source is the same but has made many changes.

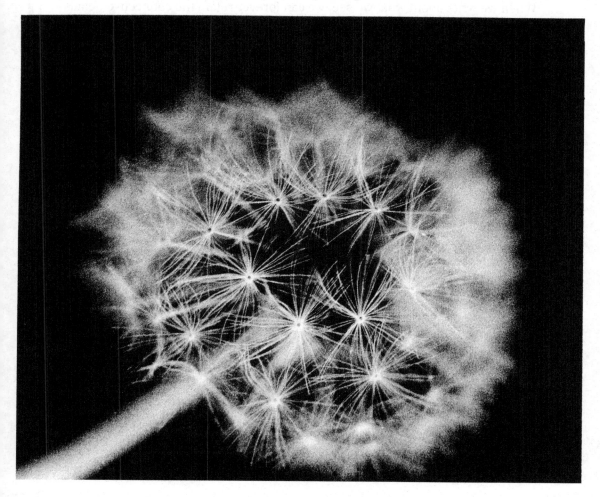

WORDS AS SOURCES

In her teaching and in her art, Corita emphasized the importance of words. Reading and making were symbiotic and she assigned volumes to be read by the art majors–using literature as a springboard for creative ideas in any medium. The words of fine writers inspired us, broadened our experience, and illumined essential truths. We used poetry in our graphics–providing imagery beyond the visual–and words and individual letters were sources for shape and form.

Emphasis was not necessarily on the finished novel or sonnet. Meticulous observation and recording of details of daily life, found in the letters and journals of writers, taught us that a sense of wonder is not limited to visions of angels, but can be experienced while recording the activities of a colony of ants. It is in the transformation of mundane events into other realities–music, painting, etc.–that our works come into being.

When we write about what we see, we can forever retain the connective details in our sense diary, and our visual skills are enhanced by the effort of description. Don't try to make literature when you are describing how a broad, flat leaf looks with the sun coming through it. Be a reporter–just the facts. Anything we do with care, curiosity, and feeling, will be good. Time spent working with words is never wasted.

In the truthful recording of what we see, we can sometimes approach the Webster's definition of *poetical–above or beyond the truth of history or nature.* Reference books, such as dictionaries and encyclopedias, often contain factual material that seems poetical. Here is part of a description of the Himalayas appearing in the Encyclopaedia Britannica.

> *A mountain known as K2 is dominating,*
> *peak crowned,*
> *water parting.*

A source is whatever we choose to examine, exploit and redefine.
Sister Mag

assignment

Make a list of twenty-five short quotes from favorite writers. Find twenty-five quotes, not considered literature, from sources such as newspapers, periodicals, or encyclopedias that seem to fit the definition of poetical. Compare them with quotes from your favorite writers.

Take your five favorite quotes from each source and put them with five pictures of mountains.

Keep all the quotes in your sense diary for future use.

Structure: manner of building; form; construction, involved in, or caused by structure; something built or constructed; arrangement of parts (definitely has a lot to do with our investigations).

STRUC

Structures are restraints—a way of limiting. What you can build within restraints and structures is almost limitless. You will be forced by them to open up and see things within these limits, things you might have passed over if you had been "free" to wander the world or do anything you felt like doing. Was it Emerson who said he needed only his own backyard to discover all about the world? You have the rest of your life to go your own way without the structure of an assignment and you will take richer equipment with you because of this structural experience. Ideally you will learn how to build your own structure or limits which will prevent you from floundering around trying to do everything—or even from wondering what to do.

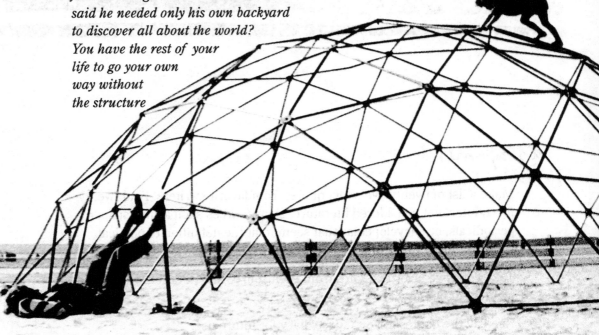

The thesaurus also includes the words *framework,* *understructure,* and *bones. Bones,* yes, bones most of all– living, dancing bones.

All good structure, like scaffolding, can be dismantled after the building is built. Scaffolding will be put up in a different shape for another building. So you are always making new structures.

A school is a structure; so are specific classes, assignments, goals, projects. These are the firm, supporting structures within which life is led and learning goes on. They are the course that study takes. All these structures are limiting. If you have a class at a certain time and place, you must be there and not somewhere else. You must be

there because otherwise your contribution (in thinking, dreaming, knowing, not knowing) would be missing from that class and it would be the poorer without you. You aren't needed to be there to get grades or pass the course–you are needed to help make the class. So the structure is there for you and you also are the structure–your particular gifts help shape it.

Corita

STRUCTURE

This chapter on structure begins with words about children and their schools. It was in this context that I began to understand what structure is and isn't. I hadn't thought about structure as being something that enabled me to do things. I thought structure meant discipline and rules. It is that–as well as being the core and frame for any successful work. Preordained rules or rote discipline are not structure; they are inhibitors of creativity when they have no real connection to the project at hand. Structure makes our creativity possible, by providing a framework to build on.

But sometimes we confuse structure with discipline. Teachers speak of structured or unstructured classrooms, but the real message often seems to be disciplined or undisciplined (perhaps more to the point, rules or no rules, i.e., *unruly*), and has little to do with structure.

When my children were very young they attended a private school where they were allowed to do just as they pleased. In this insular little world where the child was absolute monarch, there was little structure and adult rules did not apply. There was no connection to the real world, no sense of purpose or tradition. Instead, an artificial environment was created by the enthusiastic practitioners of a new educational philosophy–in which a certain jargon and preciousness were prevalent.

a school in India

a school in East Los Angeles

One mother felt humiliated when one of her children brought home a painting and she said, *That's beautiful! What is it?* All three kids screamed at her, *You're not supposed to ask that!* The word *special* was used so often it lost all meaning. Since everything was special, nothing was. Since there were no limits, the children had to choose from everything, and that is very hard. For fear of suppressing creativity they were never given a structure upon which to build. They came home from school tired and dissatisfied.

We decided to enroll them in the local public school. There, rules replaced unmitigated freedom. Neither divergent thinking nor structure (both cornerstones of creativity) were recognized. On her first day of school, my daughter was given a sheet of paper with mimeographed outlines of animals to color–but when she began to make a sun and some flowers to finish the picture, she was told she must keep her coloring inside the lines or her picture would get too messy.

Shortly after this I was called by the school principal, who said the school psychologist had found Tina to have severe learning disabilities. She had been shown a drawing of a house and a school (on the same sheet of paper). Her task was to draw the shortest way from one to the other. The psychologist said she had been unable to follow his directions. I asked him what her response had been–she walked the shortest path to school every day and I couldn't understand her failure to relate to this drawing. Then he told me that she had picked up a pencil in each hand, and starting at mid-point drew lines to the school and the house simultaneously, saying, *It's only half as far this way.* My terror turned to uncontrolled laughter and later to pity for that earnest young man. From his "disciplined" point of view there could be only one right answer.

boys reading from books they've made

It was about this time I started
school again at Immaculate Heart.
I often asked my kids for help
with my homework–they would
draw or make something and I
would work from it. When Corita
asked my little girl to do a
drawing for a book she was
preparing, Tina was ecstatic. She
worked long and hard, paying
careful attention to the
requirements for size, media, and
subject (her structure). She felt as
if she would be making a real
contribution to the big outside
world. I began to see that the kids
were happiest when they worked
for a real reason. I saw they liked
being part of the whole world–
not just put in the center and
made to feel "special." I saw that
structure and discipline are two
different things. Tina made her
own discipline when she worked
within a solid structure.

Tina's drawing for Corita

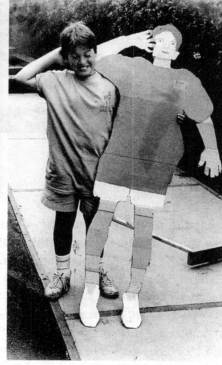

Sixth graders from the Center for Early Childhood Education made three-dimensional life-size self-portraits after visiting a Red Grooms show.

Clouds, *painting by Therese Gorman*

LIMITATION

Limitation is what differentiates a flood from a lake. In the making of things, limitations allow you to choose from something rather than everything. If two people decided to make some paintings about clouds, the outcome would be very different, depending on the base from which they started. For example, the first person says, *I feel creative today, so I'm going to paint some clouds*. The second person says, *I'm really turned on by clouds–they fascinate me and I want to explore them further*. It's more important to the first person to be "creative," to give himself a label. His goal is to express his creativity, which is such a vague and ambiguous notion that there is nothing on which to base a form for his work. The second person focuses on the clouds, which are real things rather than abstract ideas. Real things have inherent limitations. From these, she can begin to define goals, and then structure. She then has enormous resources available to help her to find out about her project, to distill its essence, and clarify how she will proceed. The first person can only research creative expression, since that is his goal–and research on creativity can be found only in words and theory.

Simon Rodilla built the Watts Towers–those soaring spires–next to some unused railroad tracks in southeast Los Angeles. Old plates, beer bottles, and other refuse of civilization adorn them–and they are the most outrageously beautiful things I have ever seen. When asked why he had built them, Rodilla said he did so because he wanted *to make something big on the landscape.* He didn't say he wanted to be a great sculptor.

When the focus is on something tangible, the course of the thing will carry you, rather than you carrying it. When the limitations are natural ones (size, shape, and kinds of clouds), you don't have to wrestle with abstract windmills. You can then apply your energy to the matter at hand.

Deadlines are great organizers. When you begin a project, set yourself a deadline. When your *needs (a state of circumstances requiring something, or the something required), goals (any end aimed at),* and *deadline (the latest time by which something must be done)* are clear, there will be an inherent structure.

Chinese clouds

In my projects and assignments I work very hard on structures within which students can work–structures that will be supporting enough–a kind of scaffolding. The structure should stand high enough to paint those parts of the building they want to paint and it should not restrict how they should paint it. And when they finish, the structure should be dismantled and put away...perhaps to be reused in another form at another time.

Corita

71

NEED AS STRUCTURE

When Ray and Charles Eames were asked to be advisors in the founding of the National Institute of Design in Ahmedabad, India, they described their design priorities in their opening day statement.

> India's immediate problems and needs are well defined: food, shelter, distribution, population. Such ever-present statements of need should block or counteract any self-conscious need to be original. You must put consciousness of quality–selections of first things first–(investigate which are first things) on the basis of survival, not caprice.

> Of all the things we have seen and admired during our visit to India, the lota–that simple vessel of everyday use–stands out as perhaps the greatest, the most beautiful. The village women have a process which, by the use of tamarind and ash, each day turns brass to gold. But how do we go about designing a lota? First, one would have to shut down preconceived ideas on the subject and then begin to consider factor after factor.

> The optimum amount of liquid to be carried, fetched, poured, and stored in a prescribed set of circumstances.

> The size and strength and gender of the hands (if hands) that would manipulate it.

> The way it is to be transported: head, hip, hand, basket, cart.

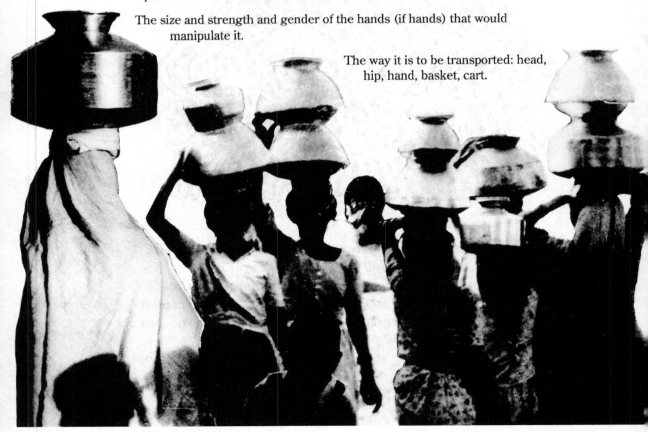

The balance, the center of gravity, when empty, when full, its balance when rotated for pouring.

The fluid dynamics of the problem, considered not only when pouring but also when filling and cleaning and under the complicated motions of head carrying, slow and fast.

Its sculpture as it fits the palm of the hand and the curve of the hip.

Its sculpture as complement to the rhythmic motion of walking or a static pose at the well.

The relation of its opening to volume in terms of storage uses, including objects other than liquids.

The size of the opening and inner contours in terms of cleaning.

Heat transfer—can it be grasped when hot?

How pleasant does it feel—with eyes closed? eyes open?

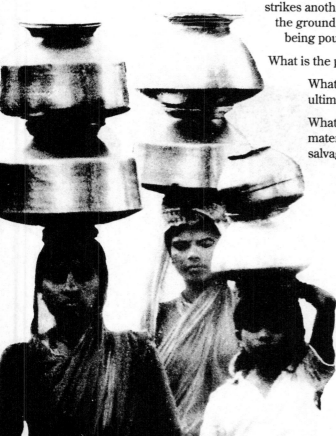

How pleasant does it sound when it strikes another vessel, is set down on the ground or stone, is empty or full or being poured into?

What is the possible material?

What is the cost in terms of ultimate service?

What kind of investment does the material provide, as product, as salvage?

How will it look when the sun reflects on its surface?

How does it feel to possess it? sell it? give it?

Of course no one man designed the lota, but many men over many generations. Many individuals are represented in their own way through something they might have added or may have removed or through some quality of which they were particularly aware.

73

What I always wonder about free verse
is where the stops are.
I want to know what I'm working against.

Robert Frost

assignment

Carefully lay out some kitchen tools on a clean white piece
of paper or on some beautiful textile. Look at the forms of the tools
and see how their use evolved. List, as Eames did, the requirements
or properties of the object. See them as works of art. Read the Badger's
dissertation in *The Once and Future King* by T. H. White for another
viewpoint on how needs and requirements define the final structure
of an object.

When I began this book, I went to the classroom of Paula Rao, an IHC graduate, for ideas. It was Author's Tea; the second and third graders were to read from books they had written, printed (typeset), and illustrated. They had bound them and made beautiful covers. The books themselves were only a small part of the festivities. On a long bulletin board hung autobiographies the children had written, accompanied by photographs of each child. Parents and kids were happy, proud, and excited. Everyone wanted to be there.

Later Paula and I talked about the day—especially about one small boy whose autobiography was so poignant. He wrote, *I came from Chicago with my mother and my cat. . . . My life is very hard to do.* That little boy, with such sadness in his life, looked absolutely radiant when he stood on the stage to read from his book, framed by a simple orange cloth banner. The banner had a yellow sun in just the right place, so that each child seemed to have a halo around his or her head. I asked Paula about the banner—how did she decide to do that? *That's nothing,* she said. *The parents usually want to take pictures and there is that big bright window behind the stage. There would be too much back light. It wasn't meant to be art, the children are the art.*

Sometimes the needs define the goal. At other times the goal defines the needs. They are often inseparable and interdependent. The banner is an example of that synthesis.

STRUCTURE

The way to liberty has nothing whatever in common with any willful rebellion or calculated originality; least of all has it anything to do with functional self-expression. Ascertained rules should be thought of as the vehicle assumed by spontaneity, rather than as any kind of bondage.
Ananda Coomaraswamy

third grade class at Immaculate Conception, creators of the wall

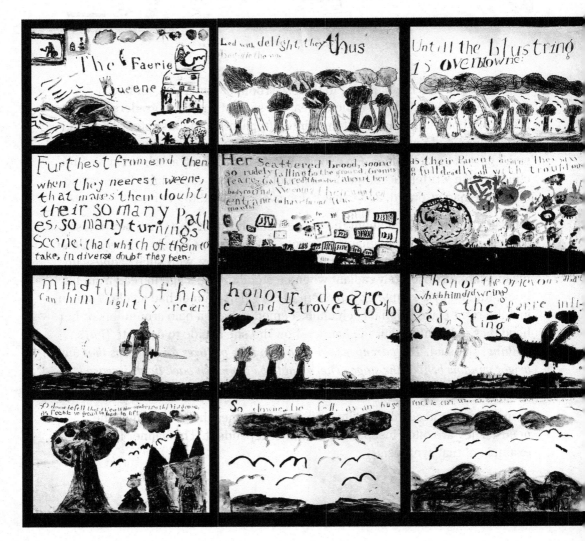

Charles Eames contended that if we would consider problems in light of the next biggest problem, we could save ourselves a lot of work. If Paula had set about to design and make a beautiful banner, she might not have solved the problem of the back light and might have lost sight of the meaning of the day. The second thing that reminded me of Eames was his statement that the basic problem of design is to care. Author's Tea had been a wonderful example of how true that statement is. Paula's caring generated caring in her family–her husband and mother were both on hand to help–and in the children and their parents. I've never seen such happiness and pride–I wish my children could have been in that classroom when they were second graders. But it was also an excellent example of how essential it is to have a structure that supports–but doesn't choke–the children's natural creativity. Such a structure–formed out of the process of defining goals and then achieving them–almost guarantees success.

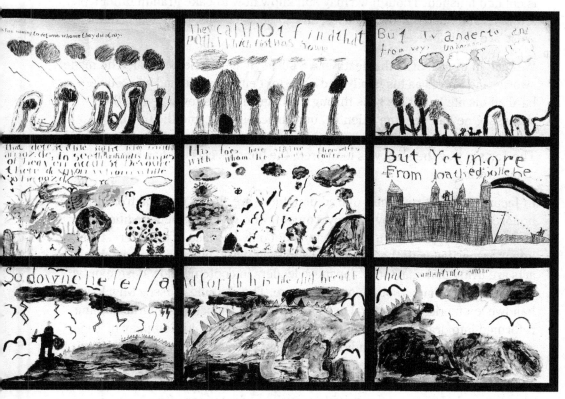

Kathy Mason's third grade
class illustrated Spenser's
The Faerie Queene
original size 2½ x 63 feet

TRADITION

A kind of structure we don't have much chance to know about is the structure made by tradition. Tradition guides and counsels and acts as restraint. Tradition defines goals and is a data bank of technical and aesthetic ideas. Tradition provides vocabularies of shapes, tools, materials, and ways of working.

Those things that were told to our fathers and mothers by their fathers and mothers—on down the time tunnel—can be as simple as how to make an apple pie or as complex as how to build a house. The unique systems that have been passed on and refined will always be recognized as belonging to your family because of the way the apples are seasoned or the way the wood is cut and finished. Though we may still know how to bake grandmother's pie, few of us still build our own houses, and some traditions, particularly in the West, are gone forever.

We read in the paper of the death in a Sicilian village of the last man who made swords and knives as his family had done for centuries. He had worked very hard all his life to put his sons through college and was rewarded by their success. One had become a dentist, one an accountant, and the third, a computer programmer. None of them knows how to make knives or swords. The certain way the steel was tempered, the handles carved, has been lost to our world.

In Japan, the great respecter of tradition, there are "living national treasures," honored and supported by the government, who carry on their traditions. Young people apprentice to the masters, not only because of the interest and honor associated with the individuals and their work, but also because these arts are living and vital today. Japanese leaders in contemporary design draw heavily on tradition as source and structure. The clothing of Issey Miyaki uses handwoven fabrics and natural dyes to reflect the shapes of samurai clothing, reformed into dramatic contemporary fashion. The Suzuki Company of Toga, one of the most innovative and exciting theater groups in the world, creates works with traditional Japanese forms (costumes, music, etc.) combined with contemporary theatrical concepts and themes. Their repertoire includes works of avant-garde Japanese playwrights as well as adaptations of such classics as *King Lear* and *Clytemnestra*.

Suzuki Theater of Toga in a performance of Clytemnestra

STRUCTURE

In our country it sometimes seems as if everyone was in such a rush for gold or land that the weight of tradition was too much to carry. Settlers were often in situations where improvisation was imperative and perhaps they couldn't foresee a time when old ways would be useful. Unfortunately, "Yankee ingenuity" is not the best answer to everything. Traditions arise from small bits of information that have accumulated slowly. They can't be revived when dead and we can't sit down and make up new ones. These small, obscure ideas or ways of working help us bridge the gaps where we lack sufficient knowledge or expertise, and are vital elements for tying the structure of our lives together.

A fine example of a flexible tradition comes from the Navajo people. Their art reflects their genius to absorb the ideas and skills of other cultures and make them their own. Ready-made yarns freed the weavers to spend their time on developing more intricate designs. The advent of aniline dyes inspired the brilliant eye-dazzler patterns. When traders showed the weavers prayer rugs from Persia to copy, the Navajo wove the unfamiliar into their own tradition and techniques.

Navajo weaver, circa 1894

Human beings have always made things. Potters still make pots, weavers still weave cloth, and we needn't worry about being original. Even when we borrow from other traditions, our work will be ours. Don't worry about making an absolutely new thing–something that has never existed. (We usually stumble on those things by accident in the pursuit of simpler goals.) We give form to the familiar. Traditional information may be ancestral but not necessarily of our ancestors. Archibald MacLeish wrote:

> …what humanity most desperately needs is not the creation of new worlds but the recreation in terms of human comprehension of the world we have, and it is for this reason that arts go on from generation to generation in spite of the fact that Phidias has already carved and Homer has already sung. The creation, we are informed, was accomplished in seven days with Sunday off, but the recreation will never be accomplished because it is always to be accomplished anew for each generation of living men.

The concepts of *limitation, structure,* and *boundary* are sometimes looked on as inhibitors of our creative energy. But with the whole universe to choose from, we should welcome these concepts and see them as providing valuable information that will help define our goal. The tools and materials should demand some struggle too. Felt pen markers can't do as many things as paint–but if that is all you have available, think of them as being completely alien and invent new ways to use them. Define your goal.

Charles Eames wrote:

> Consider a sculptor attacking granite with hand tools. Granite resists such
> attack violently; it is a hard material, so hard it is difficult to do anything bad
> in it. It is not easy to do something good, but it is extremely difficult to do
> something bad. Plastilina, though, is a different matter. In this spineless
> material it is extraordinarily easy to do something bad—one can do any
> imaginable variety of bad without half trying. The material itself puts up no
> resistance, and whatever discipline there is the artist must be strong
> enough to provide.
>
> I feel about Plastilina much as the ancient Aztecs felt about hard liquor.
> They had the drinks, but intoxication in anyone under fifty was punishable
> by death, for they felt that only with age and maturity had a man earned the
> right to let his spirit go free, to self-expression. Plastilina and the air-brush
> should be reserved for artists over fifty.

*There's no trouble
in knowing what
you want to say.
it begins
in keeping out
the rest of it.*

Kenneth Patchen

Tools and materials further help to define structure. The more you struggle,
the more definition of intent will be there. If answers come too quickly, it often
means that we don't really understand the question, and need to keep asking.

ONE BEAD AT A TIME

This book came about from another way to make structure. That is the sifting and sorting method. Corita gave me many large cardboard boxes filled with notes, articles and student work she had saved from years of her classes. I made up what I thought would be the chapter titles and tried to put all the bits and pieces together under those headings. It didn't work at all. The chapter titles were silly and self-conscious—straining to be poetic, the content in parables. One day as I struggled along, my friend Jean-Paul dropped by to see a beadwork piece that had just come from India. It was ten inches wide by thirty feet long and illustrated a complicated love story and elopement, with beads no larger than sesame seeds. *Jean-Paul,* I asked, *how on earth could a person do this—always making the right decisions, making it look as if it had been born, not made.* He rubbed his chin thoughtfully and answered, *Well, I think first you take a white bead. . . .*

That answered a lot of questions for me about how to do this book. The material was the structure and not to be imposed on some other form. It would make its own shape—its own chapter titles.

assignment

A structure is a series of short-term goals. These limited goals can lead to the completion of projects so fantastic that you might never have undertaken them because they seemed overwhelming. The assignment is for you to make a list of five short-term goals, define their structure, and then make a list of five long-term goals of which the limited goals could be part.

*detail from
beadwork scroll,
Gujerat, India*

For example:

> Goal–to research a period of history and how people lived and looked in a certain time and place.

> Goal–to collage and paint ten cardboard cartons with pictures and words related to the results of the research.

> Goal–to construct three puppets also related to the research.

> Goal–to write a script about the three characters (also related to your initial research).

> Goal–to research music and other sounds of the time.

The bigger goals could be a puppet play or an exhibit with the script printed on the boxes. The boxes are for space division and background. How the puppets are to be made or used will influence dialogue. Sound is a very important element. If you decide on a static tableau, it wouldn't be difficult to automate a hand or head for the puppets to give them a slight occasional movement.

As you structure and accomplish each goal, there will be rewards along the way. When you complete the whole project, you will have something to show. In fact, you will have a show.

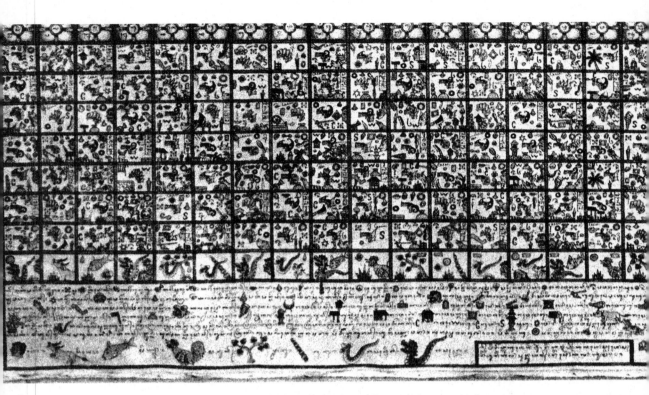

People have always needed to reckon time. The cyclical activities of the sun and moon mark our years and months and time indications within the year are marked by seasonal occurrences. Centuries ago Hesiod wrote that when one hears the cry of the migrating crane it is the proper time for ploughing and sowing, when the snail climbs the plant there should be no more digging in the vineyards, and when the thistle blooms summer has come. Calendars we buy will divide our years into days and hours, but though holidays might be marked, the personal events and rites in our lives are to be added by each of us.

There are great examples of calendars from all times and all over the world to use as sources. Illuminated manuscripts of ancient Celtic calendars, the Aztec calendar, Greek religious calendars, calendars denoting planting seasons and festivals, and the calendars from India showing the god whose day it is. Most complex of all is the Balinese calendar, which regulates every aspect of life. These are all great idea banks.

Since calendars have well-defined functions, they supply structure upon which to build. Something as obvious as deciding size and placement will begin to make the form for your project.

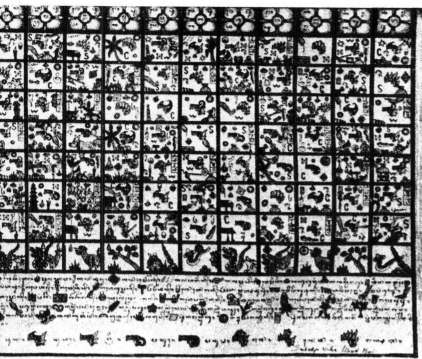

Balinese calendar
above: detail

assignment

Make a calendar. Begin with the basic list of requirements.

Where will it be?

Who will use it?

Will it include holidays and other special days?

Birthdays of family, friends, famous people, your dog?

Zodiac signs, phases of the moon and planets, natural occurrences (the time when the orange tree flowers, etc.)

Will there be space for appointments, jobs, and deadlines?

What's happening–concerts, exhibits, when is the circus coming to town?

Of what material will it be made?

What will you use to write on it?

Can you see it from across the room?

Should the pages indicate weeks, months, days, hours–or all of them?

To fill out your calendar, begin by gathering a stack of fifty sources. Use poetry, pictures, recipes–whatever you like, but don't judge for good or bad. Making a calendar is a good example of how form follows need and is relevant to any project. If you trust the process there will be more than function, there will be beauty.

life
candle flame
wind coming

jelly in a vise

a liar
an egg in mid-air

most beautiful
just before

if you know a song
sing it

Dictionary definitions of the verbs *to relate* and *to connect* include the following. *To relate: to tell, recite, narrate, to interact with others in a sympathetic relationship, to combine, unite, join, bind, bond, and fasten, to bring to bear upon, tie in, bring into relation with, touch, place side by side, or lay one thing next to another. To connect: the act of connecting, the state of being connected, and the means of connection.* Relationship includes the ideas of kinship and involvement. Juxtaposition is putting things close

CONNECT

In The UCLA Monthly *(March-April 1986), Kenneth Trueblood said of his colleague in chemistry, Donald Cram:* What is remarkable about Don Cram is that he is bright, very hard-working, and he has an exceptional imagination. The world is full of people who possess one, or even two of these qualities, but there are very few who possess all three.

Any teacher would like to give these qualities to each student and that is not possible. But it is possible to assign tasks that stretch their minds, that necessitate hard work and expand their imaginative powers— at least they can be started on their way. To a certain extent, intelligence is measured by the ability to make connections and see new

enough mosquitos
sound like thunder

pleasure flower
pain seed

dreamed that his pen blossomed

from *Asian Figures*
collected by *W.S. Merwin*

together. Sometimes contrast is implied. All these definitions involve the *creative process. Create: to cause to exist, hence to invest with new form, office, or character. Process : the act of proceeding, progressing, and advancing. A phenomenon that shows a continuous change in time is the process of growth.* The word *process* is preceded by *procede* and followed by *procession.* Sometimes these words overlap and share meanings and shades of meaning.

&CREATE

relationships and there are many ways to help students use this gift. Small children have almost endless imaginations. (Cram's youth on the farm with its repetition of chores forced him to invent his own games and entertainment.) Imagination often gets stamped out by the need to conform, and the older the child sometimes the harder it is to get him

to revive his early gift. By ingenuity of assignment the teacher can open up what has been narrowed down.

One of the tricks I use is to show two unrelated films on two adjacent screens from two projectors simultaneously, with either sound track (or totally different sound). Then we view them with the other

sound track. Seen as if they were one film, the two films create many new connections that would never have occurred if each film were seen independently.

I know of a record by John Cage where he tells many stories—some long, some short—each in one minute. The long ones are spoken quickly to fit. The sounds around him while recording are all part of the reading and it helps us to see that each sound in the world can be heard in a new way, or that each square inch of a painting can hold surprises. Best of all it is a delight to listen to a well-made piece. Anything well-made is healthy nourishment for people who are

trying to create. There is almost nothing that is not related to art. When teaching, I aim to present a wide range of ideas and images to confuse students out of their assumptions of what art is and how a class is taught. This gives them a broader horizon and more material from which relationships can be made.

How can we become bright, hardworking, imaginative people? By learning how to use our connecting ability to make new relationships and by getting used to working very hard in ways that will develop our imaginations. The very

word imagination *implies that you are into territory no one has ever been to before. A rigid discipline that demands one "right" way is confining and limiting. We need one that is liberating and boundless, that allows us to make new connections in completely new situations. This is a* *discipline that accepts assignments from teachers or life that include hard work and the development of imagination.*

Corita

We still ask boys to think, as in the nineties, but we seldom tell them it is just putting this and that together; it is saying one thing in terms of another. To tell them this is to set their feet on the first rungs of a ladder the top of which sticks through the sky.

Robert Frost

There are moments in the creative process when one is aware of great things happening, but I never feel that is the "Creative Process."
It is only a punctuated moment of excitement in the larger process. The hard times, too, are part of the creative process; for example when I can't sleep at night or lose the meaning of what it's all about.

It can be a time of drudgery–a dirty, collecting time when I sharpen pencils or clear work space, but we know that somehow these things are necessary when we go to do a job or make a thing. When we go to build a new building we must first clear away the debris. We call those the difficult times… the dark times. I suppose these times are much the same as winter and late fall when things seem not so bright and flowery, but lovely and dignified in their own way, a retiring way, as things get quieter. All the leaves are gone from the trees–only the seed pods hang on, but the wind is blowing and they can't hang on very long. Then the trees look dead. We know this is the beginning of a very deep creative process out of which will come spring and summer. And if you can think of the most difficult moments of your life and you can feel those times to be part of the creative process, though very painful (I think it must hurt the trees to lose all their beautiful leaves), then that is, for me, really working, really creating, it just isn't yet the finished product.

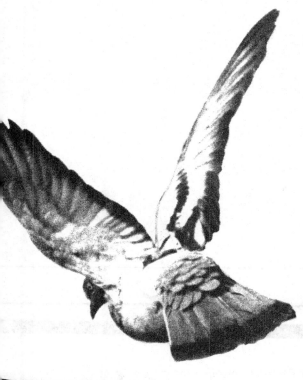

I think what contributes most in my
life to allow me to open to new
experiences is a sort of sheer
frustration with where I am, and
I try to move out of that place, and
that can lead to new experiences.

The way I choose to put the messages
of my life together into a picture is
related to all I have ever seen
through the eyes of other picture
makers and through a constant kind
of looking I do myself.

What is my own is the constancy of
observation of forms and the
investigations of ideas and feelings
as they combine into the final object
to which I sign my name and for
which I assume responsibility.

Everything is meaningful to us: to
believe otherwise is like saying that
only our hands are being used for
painting. But no, our feet are taking
part in it; the feet couldn't stand
without the floor or the ground and
the hands couldn't paint without the
feet standing on the floor or ground.

Corita

There are very few human beings who receive the truth, complete and staggering, by instant illumination. Most of them acquire it fragment by fragment on a small scale, by successive developments, cellularly, like a laborious mosaic.

Anaïs Nin

The making of connections defines and makes possible creativity. These processes tap into what we know and feel, but have not yet (or cannot be) articulated. They elude the rational, conscious mind—which tends to constrict, label, categorize, and demand logical explanation.

The synthesis of creativity and connections is a process we are all experts in. We use it each night when we dream. Our dreams contain symbols, which are a condensation of images and ideas that share certain characteristics—not obviously connected. Symbols are a very efficient method of communicating many things, on many levels, all at once. Dream symbols are the unconscious mind's way of communicating with the conscious. We all know from first-hand experience how compelling that process can be—in the way we learn from our dreams, when the feelings of a particular dream linger on throughout the day, and as the memories of certain dreams stay with us for years.

In the paintings of the French artist René Magritte and the American Joseph Cornell, we are constantly challenged to question our conventional way of seeing the world. They cause us to laugh at our habit of labeling things, of expecting certain relationships always to exist—and others not to be possible.

They throw our conventional side into crisis—forcing us to experience in a new way. They do this by joining things that don't normally go together; by combining three-dimensional space with two-dimensional space; by matching words with images in surprising or thought-provoking ways.

While Magritte represents the familiar in an objective way that jars the viewer out of habitual responses, Corita represents the familiar as a personal response. Her subjective, often abstract, shapes are accompanied by words—in a lyrical statement that urges the viewer to thought and action. As diverse as these artists' works are, their ability to make connections is the basis for their creative process. Virtually all discoveries and man-made creations come from this innate, unconscious ability to make connections.

serigraph by Corita

95

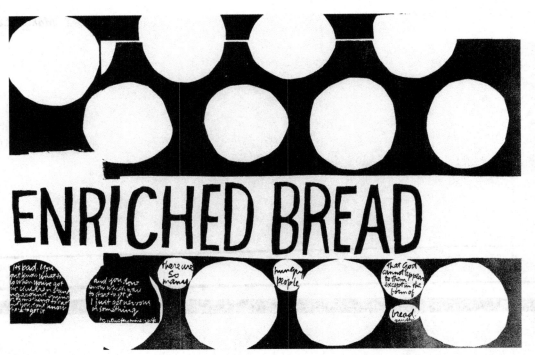

serigraph by Corita

The condensation of visual and verbal connections between universal symbols, words, and the stuff of everyday life–motherhood, food, nature, money, cars, phones, airplanes, and so forth–leaves a much stronger impression than the parts themselves. Advertising agencies use this phenomenon of unconscious connection in making their campaigns. By combining well-known words and images in new and surprising ways–with the product being sold–a powerful and lasting impact is made on the viewer on an instinctual, feeling level, that results in sales.

Creative power is often mistakenly attributed to inborn talent. Genuine creation is not merely the product of a gifted person. It is the result of the successful arranging of complex activities and parts according to specific goals and needs, and above all of the ability to connect one thing with another–as is demonstrated in the most successful advertising campaigns.

Gaining a wider perspective is like opening a window into a stuffy room—
the whole atmosphere changes
and the fresh breeze carries alternatives to our habitual ways of reacting.

Tarthang Tulku

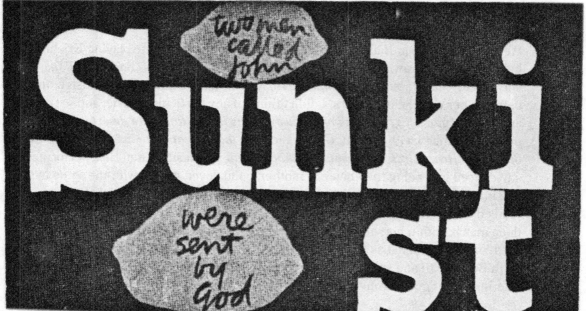

detail of serigraph by Corita

T. Balasaraswati, India's great Bharat Natyam dancer

We sat at the table in Bala's small kitchen. She posed as the flute-playing Krishna to help me make a drawing for a poster announcing her brother's concert. *Tell me,* she asked, *what is your favorite music?* Busy drawing the flute–which existed only between her embracing fingers, I didn't think of any particular music, and answered, *I guess it's the sound of far-away trains in the Rajasthan desert late at night.* She smiled with delight. *Good!* she said, *that's what an artist does–hears all the music. Hears birds, bells, whistles, children–all the music.* When Bala performed, she danced into being the universal mother, child, lover, or god with the same truth and immediacy as when, on the other side of the curtain, she chopped chilis, cradled her grandson, or wrapped her sari. She put her life experience into some deep matrix within herself where centuries of tradition, years of discipline, and a great inner light acted as forces to distill and make beautiful the most simple act. With Bala, earth and spirit were one. When she was ready, it all came out as an offering to her god, through her dance.

The creative process is the same, whether we dance, make soup, shoe horses–or whatever it is we choose to do in this world.

Everything I do adds up and goes into the act of painting.

I have an idea for making something or I have a commission to do something or I have a deadline... and I always have a kind of natural resistance to getting down to it. Somehow I feel that this kind of natural resistance is quite healthy—because all the information, sources, and ideas need cooking before they can be served. So I go on living and I go on doing what might seem to be very uncreative things like shopping or cooking or washing the dishes or answering the phone or writing letters—and sometimes the data comes out and asserts itself into my consciousness, and I live with it for a while.

Artists, poets—whatever you want to call those people whose job is "making"—take in the commonplace and are forever recognizing it as worthwhile.

I think I am always collecting in a way—walking down a street with my eyes open, looking through a magazine, viewing a movie, visiting a museum or grocery store. Some of the things I collect are tangible and mount into piles of many layers, and when the time comes to use these saved images, I dig like an archeologist and sometimes find what I want and sometimes don't.

Brooke MacIntosh, master farrier

He who sees the inaction that is in action and the action that is in inaction is wise indeed.

Bhagavad Gita

Matisse gives the following example of not connecting:

> I have often asked visitors who came to see me at Vence whether they had
> noticed the thistles by the side of the road. Nobody had seen them, they would all
> have recognized the leaf of an acanthus on a Corinthian capital, but the memory
> of the capital prevented them from seeing the thistle in nature.

lotus pond

A tremendously constricting force on our contemporary society is the concept
of the professional or specialist, who deals for the most part with what has
already been done and builds on his own limits. To the extent we can approach
our job as an amateur (from the Latin *amare,* meaning *to love*) will we be
successful in our work. When we pursue a thing for love, we are free to fumble
and make mistakes. The course of our work may not run smoothly, but we are
open to possibilities, embracing everything we have contact with. Our vision is
not narrowed by convention. We notice the thistles and connect them, with
surprise and delight, to the Corinthian column.

K.P.T. Wasitodipuro, Javanese master musician

When asked what makes a good dancer, the master replied:

First, to be a good dancer, one must know the music as well as the dance.

And what else?

To be a better dancer, one must understand the stories and be able to interpret the characters being portrayed.

Is there more?

The best dancer is the one who has all those things I have told you about and is a farmer.

Javanese Proverb

Nanik Wenten, Javanese classical dancer

101

IF WE BEGIN WITH

SHALL END IN CERTAINTIES

assignment

Make a small book. Start with the cover, taking a drawing or painting or photograph for your visual material. For the words on the first page, use a grocery list from the last time you went to the market. Let that book grow—one thing leading to another—until the last page, which will contain a few lines of poetic insight (from an anthology of poetry). See how the cover photo (or other graphics) evolved to the final words. Just let it happen.

The material should be filtered through you rather than your filtering yourself through the material. Self-expression is a natural by-product of your work, because you are doing it. If the purpose of the project is to express yourself, there is a danger there will be no surprises. The growth that can happen discovering solutions to specific problems (goals) may be missed if we are too insistent on projecting a personal message.

As you make the book, keep a list of the relationships and connections that happen. Things will come together that you never planned. There will be connections between paper and thread, glue and poetry. Keep lists of things that strike you as funny, improbable, or downright silly. Respect details. Make and move on. Don't wait for inspiration. Just do it.

PATIENT WITH THEM, WE

CERTAINTIES WE SHALL

assignment

Type out some brief passages from the Bible, the Koran, the Bhagavad Gita, Zen Sutras, and Native American mythology.

When you are finished, cut away the excess paper. Cut out headlines and articles from the newspaper. Glue the typed words and newspaper clippings onto a piece of paper on cardboard. First glue a set of typed words, then a newspaper clipping, until you have used up all your typed words and clippings.

Read what you have put together and notice new meanings, connections and relationships between the two kinds of words.

When we speak of the creative process in this book, we mean the art of connection making—how to see the thistle for the first time and recognize its potential. Connections are usually preceded by much arduous, conscientious work. Whether connections are building blocks or come in the form of intuitive leaps—as in Zen—our lives are augmented by them. Psychologists use the term divergent thinking to describe one aspect of this process. And Robert Frost reminds us that learning to put one thing with another will put us on the first rung of a ladder that reaches through the sky.

Buckminster Fuller describes a genius as one who has not been damaged by education. Every child is creative—until the time when teachers, parents, and other adults in her world begin to patiently explain the way things should be, what connections can or can't be made. I visited a fourth grade class where "perspective" was being taught to puzzled kids. One small boy had put some tiny people next to two enormous cats. The teacher asked him if those were little fairies. *No,* he said, *those people live two blocks away and are just visiting the cats.* Natural inventiveness and playfulness give way to rewards for right answers—right according to the bias of the authority. Later on, these children, grown into young adults competing for admission to universities, are penalized for "right answers" and rewarded for creativity—the ability to make connections and to play around with materials and ideas. This is nowhere more evident than in the sciences; the world would benefit greatly if this were true in political science and statesmanship as well.

Most of us have been damaged by education, but we can take steps to reverse this damage. Many books have been written on creativity and the creative process. Some are insightful and helpful, some complex and cerebral. Often our best sources for insight into creativity are not in books about this subject but in reading the words of artists, scientists, or musicians. Read books of mythology and history or biographies and novels. You will make your own connections with the creative process. Read words written (or spoken) by artists—how they see and what they try to record.

One night I was going through some old notes and found the phrase *to create is to relate*. Those words were so neat and nice to say that I thought I knew what they meant. But the more I said them, the more I wasn't sure. Corita had said them many years ago in a class called "Art Structure." I called and asked her:

Do you mean relate, in the way we tell things or do you mean relationships—one thing with another? Or is it something about making connections? Or what?

Yes, she said.

assignment

Using a finder, cut out a hundred four-inch by four-inch sections of photos from a magazine. They may be details or complete images, but keep in mind that they will be put together in a book. Find twenty-five poems you like and place them with the photographs. Look at the book again in two weeks and write three lines on each page about the connections, visual and poetic, that were made.

A tenacious searching for relationships and an open-minded attitude that lets connections happen will bring about some personal and beautiful singing—singing you didn't know was there, singing that was unforeseen and is unpredictable in its course. But this singing is no "happy accident," though observers who hear the results and not the struggle might call it that because what they hear is the function of a long, circuitous process, which often had little to do with the song.

*How to live.
How to get
the most life.
As if you were
to teach the
young hunter
how to entrap
his game.
How to extract
its honey from
the flower
of the world.
That is my
every-day
business.*

from Thoreau's Journals

assignment

Cut the pages of a magazine into five-inch sections. Paste the sections vertically, edge to edge, until they form a strip thirty-five feet long. Score the strip irregularly in many places and then fold it.

Unfold the strip and stand it up and fashion it into a maze with walls five inches high.

Write down twenty-five things that you can see in your maze. Remember one thing that happened to you at home and write down twenty-five things in your maze that relate to that.

When you have worked very hard at all the parts of this assignment, you should be very tired, so you might relax and drink coffee or beer or close your eyes. Later on you might recall the experience and write about it. You will have many relationships that will give you lots of ideas to live with.

FILM

One form of this kind of work–relating, connecting, and the like–is film, which is a new literature, craft, and art. The making of a film involves many people of diverse skills and experience. In this art form photographs, words, and music are taken out of their original context and put together in a new way for the first time. This could be a definition for the art process, as it moves beyond matching and labeling. In film we hear poetry, music, and sounds of the natural environment and we see visual art in color, form, shadows, and shades–and in the illusion of movement.

Keep in mind the assembly of this sensory material as you do the next assignment. When we work and make in this way we are like the filmmaker. It would be good to do the following exercise with other people.

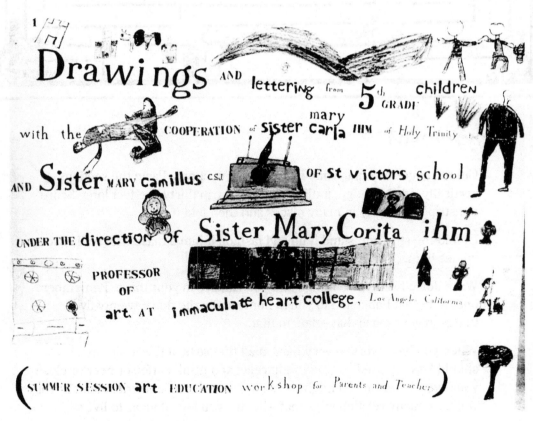

placard made collaboratively, like a film

assignment

Gather the elements for a film. Find ten photos of people you are familiar with. Find pictures of flowers and relate them to each person's photograph. (The job is to connect and relate, not only match and label.) Gather words from the following sources: poetry anthologies, poetry found or made from newspaper headlines, the surprising muse on the labels of canned goods and bread. Listen and watch for the most persuasive piece of advertising on television. When you go to the library, walk down any aisle and write down the titles of the first ten books with red covers that you come to. Relate the words to the pairs of photographs in a way that best describes your feelings about each of the pairs. Add music. Music can be any sound you think relevant.

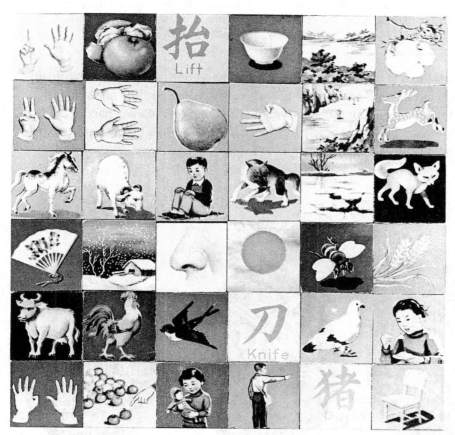

collage of Chinese alphabet cards

QUALITY

The dictionary tells us that *quality* means *peculiar or essential being; nature. An attribute; characteristic; a distinctive trait, power, capacity, or virtue. Excellence of character; as, the thoroughbred shows quality.*

Paul Rand's definition hangs in the Eames office:

> The concept of quality is difficult to define for it is not merely seen, but somehow intuited in the presence of the work in which it is embodied. Quality has little to do with status, respectability or luxury. It is revealed, rather, in an atmosphere of receptivity, propriety and restraint.

> Quality is concerned with the weighing of relationships; the discovery of analogies and contrasts; with proportion and harmony; the juxtaposition of formal and functional elements—with their transformation and enrichment.

> Quality is concerned with truth, not deception; with ideas, not techniques; with the enduring, not the ephemeral; with precision, not fussiness; with simplicity, not vacuity; with subtlety, not blatancy; with sensitivity, not sentimentality.

With the simplest project, try and think of it as a contribution to the world and approach the making as children do—with great concentration and pride of craft. Don't worry about embellishment or meaning—love each part of the process without judging some parts more important than others, and make it the best you can. The outcome will have quality.

When you are not separate from the creative process, time ceases to exist. You might start to feel tired and suddenly realize that much time has passed. It isn't necessarily a happy time—and may be very difficult to start if it is a job or an obligation. But if you start with all the concrete needs and proceed in a thorough way—the creative process will take over and you will forget whether it is work or play. Working in the here and now is one of the most uncontaminated ways to work.

Corita

above: Tanya Osadka dyeing eggs–traditional wax-resist method

below: Ukranian Easter eggs from Mrs. Osadka's collection

JUXTAPOSITION

Remember the advertisement, *Come Alive! You're in the Pepsi Generation?*
It shows youthful, exuberant, beautiful people demonstrating their zest for life.
If that ad is put next to a photo of a Nicaraguan mother running from gunfire
with her wounded child in her arms, the effect is very different. The new piece
now has the quality of a parable. This is the power of juxtaposition. Juxtaposition
uses contrast and contrast surprises. These surprising relationships contain
ambiguity and more of the mystery of life. This set of new relationships has
brought about hundreds of new questions, ideas, and associations. The
bringing about of these new things is part of the work and nature of art.

assignment

When you put colors next to other colors, they change.
When you play Bach's third Brandenburg Concerto as an
accompaniment to slides of people walking down a busy New
York street, you might have very different responses than if you
used a heavy metal band. This assignment is about the
juxtaposition of dissimilar elements.

Find five variables:
 color
 music (or sounds)
 synonyms (visual)
 antonyms (visual)
 words

to go with photographs of:
 a man-made object
 a child playing
 a woman working
 a dog running
 a landscape

WALLS

In Corita's class, a *wall* was any wall-sized picture, combining images and
sometimes using words. The size of the wall was determined by the last
fraction of available space. Projects at IHC included murals on buildings,
Corita's commissions (often done as class projects), theatrical back-drops and
time-lines—the wonderful device perfected by Charles and Ray Eames to
present a rich accumulation of data in the context of time. Corita used the term
time-line for any project whose purpose was to show layers of relationships.

The Bride and Groom *was painted by Los Angeles artist Kent Twitchell. It was commissioned by Monarch Bridal and Tuxedo owner, Carlos Ortiz (the groom). The mural rises seventy feet above Broadway at 2nd Street in downtown Los Angeles. Twitchell worked on the mural for four years (1972-1976). Since then, his enormous figures have grown throughout the area—many freeway underpasses and tall buildings reflect his artistry.*

Remember Gully Jimson in the Joyce Carey novel, *The Horse's Mouth?* Gully went mad when he saw a blank wall because he needed to paint it. Walls can affect people that way.

If it is difficult to find unpainted walls, or ones whose owners would let you paint on them, you can use paper temporarily fastened to a wall. The paper needs to be heavy enough so that it won't ripple or buckle when you add paint or glue. It should be strong enough so that when sections are joined together, the surface will remain flat and not develop creases or humps at the pressure points. Some shelf papers are adequate and come in rolls three feet wide. The best wall material is found in photography supply stores and is used as background by photographers. Rolls of seamless paper come in eight-foot widths and lengths up to twenty feet. The paper is extremely durable and accepts paint and glue very well. With a continuous roll, it is a good idea to cover the sections not being worked on so they stay clean. If you use smaller pieces, work on one section at a time and join the finished pieces with strong tape.

A wall makes a fine research tool when the time-line format is used. It is large enough to present a broad range of data, and connections that might be overlooked on the linear printed page are easily seen. More than one dimension may be used and more than one medium. It is a superb device for visualizing synchronicity. The viewer is presented with a rich collection of information in a pre-connective state and is challenged to make her own relationships.

Charles and Ray Eames created a magnificent time-line to accompany their exhibit, *The World of Franklin and Jefferson.* The top line shows current events and general information. The next line shows events in the lives of the two presidents. The bottom line highlights the life spans of writers, poets, painters, politicians, warriors and musicians, who were the interpreters and rulers of their world.

Visual materials–facsimiles of handwriting, photos, paintings–show how the people looked, how their houses and their tools looked. We see their words written in their own hand. A flavor, a pulse, a rhythm of life emerges. We relate the richness and complexity of their lives and times to our own. With a time-line, maker and viewer are both greatly enriched.

right: detail from the Franklin
and Jefferson time-line

1683 William Penn's treaty with the Indians
Bacteria discovered by Leeuwenhoek
The Turks besiege Vienna

1693 William and Mary College chartered in Virginia

1702 Anne, queen of

1703 St. Peter

1704 N
F
n
b

1686 Boston has eight bookshops by this date

1687 Newton's *Principia Mathematica*

1688 Deposition of James II of England;
the "Glorious Revolution"

1696 Captain Kidd becomes a pirate

1689 King William's War between French
and English colonists (1689-97)
Beginning of seven decades of French, Indian
and British contention for control of the fur trade
and the eastern part of the North American continent
William III and Mary of England (1689-1702)
Locke's *Two Treatises on Government*

1698 Parliament opens slave trade to private merch

1699 Peace of Karlowitz;
the end of Turkish power of offense in

1700 Samuel Sewall's *The Selling of*
first American tract against sla

1692 Salem witchcraft trials
Patent granted for post office in America

1701 Yale College founded
War of Spanish Success

William III

Anne

A souvenir of

The American Revolution Bicentennial Administration Exhibition

The World of Franklin and Jefferson

designed by the Office of Charles and Ray Eames
with the cooperation of the Metropolitan Museum of Art in New York
through a grant from the IBM Corporation

1684 1686 1688 1690 1692 1694 1696

BENJAMIN FRANKLIN

William Penn makes a treaty with the
Indians, 1683

Cotton Mather condemns
witchcraft in his *Wonders of the
Invisible World*, 1693

Yale College founded, 1701

The Bo

Boston News

JOHANN SEBASTIAN BACH 1685-1750
CHRISTOPHER WREN 1632-1723
ANTONIO VIVALDI 1675-1741 SAMUEL RICHARDSON 1689-1761
WILLIAM PENN 1644-1718 VOLTAIRE 1694-1778
ROBERT HOOKE 1635-1703 JEAN SIMEON CHARDIN 1699-1779
ISAAC NEWTON 1642-1727 JAMES OGLETHORPE 1696-1785
SAMUEL PEPYS 1633-1703
COTTON MATHER 1663-1728 ALEXANDER POPE 1688-1744
WILLIAM HOGARTH 1697-1764
DANIEL DEFOE 1661-1731 JONATHAN EDW
JOHN VANBRUGH 1664-1726
JONATHAN SWIFT 1667-1745
JEAN ANTOINE WATTEAU 1684-1721
JOSEPH ADDISON 1672-1719 CHARLES DE MONTESQUIEU 1689-1755
JOHN LOCKE 1632-1704

Story-tellers in Rajasthan (North India) use a scroll painting about twenty feet long which is hung on a wall behind the performers to illustrate the chief events of the evening's tale. There are at least two performers—a man who accompanies himself on a type of fiddle is the main story-teller/musican, and a woman, often his wife, serves as a supporting singer and carries an oil lamp with which she illuminates the episode being described. Their children often participate, singing and dancing with their parents.

One of the most popular stories recounts the legend of the 14th century Rajput prince Pabuji, who was born to a magical woman. When her husband discovers her powers he deserts her and takes the young prince with him. In order to stay with her son, the woman transforms herself into a magical black mare upon which he will ride into battle. Over centuries, specific episodes have been added or lost, but the essence of the adventure remains the same—delighting and teaching tradition to adults as well as children.

detail of sixteen-foot Pabuji painting

This theater form is one where we find our conventional boundaries between painting, music, story-telling and puppetry have disappeared.

Another kind of wall seen today, especially in urban areas, is one covered with graffiti. Some of them are very beautiful. Calligraphic styles have emerged and, as is always the case, reflect the tool used. Roman lettering, with its serifs, came about because of the use of the chisel. The free-flowing, overlaid street calligraphy is defined by the spray can.

Two boys, eleven and thirteen, who are graffiti painters told me they did it because it was a way to get their message across, territorial or otherwise. It gave them something big to do, and they admitted that the element of danger, of being caught, was an added incentive. They said it made them feel good to paint on bridges for everyone to see.

graffiti from a wall in Los Angeles

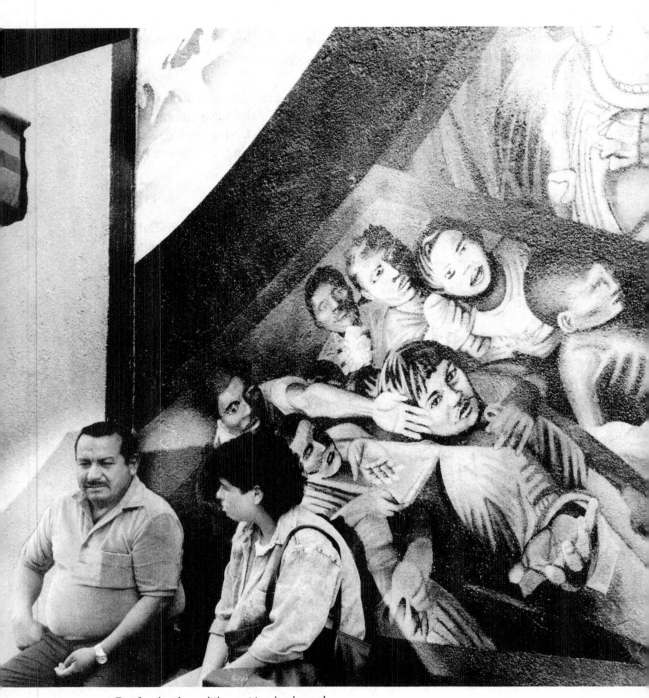

East Los Angelenos sitting next to a local mural.

assignment

Try making a family history as a time-line wall. Where were your ancestors born? Where did they work, live, have children? What work did they do? Collect pictures; articles in the newspaper; birth, wedding, and death announcements; favorite sayings; favorite music, food, books, pets; current events; famous people....

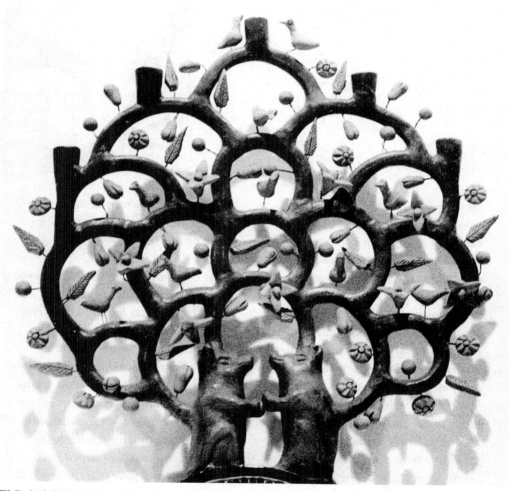

Walls don't have to be two-dimensional. This Mexican "tree of life" could be a good model.

TOOLS &

Immaculate Heart College was a small liberal arts college. Art was one of its departments. In such a situation an art department doesn't look on art the same as an art department in a large university or a professional art school. It is both simpler and more complex. It was simpler in that our physical resources were limited—both space and equipment. It was complex in that we had a more intimate relation to many of the other departments and their disciplines. As many as four professors from other departments would team-teach a single course, as well as invited professionals from off campus. Our small department was enlarged and enriched beyond the ordinary.

We cared about the way things looked and the way things were made, and we tried to pass that on to students. We used very simple tools and techniques and provided many experiences in looking and developing taste (in the best sense of the word). There are other perspectives in our world tradition than Renaissance perspective and we felt the best perspective was that which comes from you and your observation and experiences rather than a kind of

TECHNIQUES

drawing you have seen others do. We were more interested in vitality of lines and shapes–that they be alive on a page and make their own new thing than describing in an academic way what a person or object looked like originally. We were not interested in maintaining dogma. We wanted the students to make real shapes and real lines into a real picture.

We did not have a formal drawing class because students drew in all their classes. We tried to occupy their critical faculties so their intuitive faculties could work.

These are opposite procedures–to analyze is to take apart; to create is to put together. The two cannot be done at the same time. So our way of teaching drawing, painting, and sculpture was to find tools that were not usual, and to give assignments that were not usual so that the drawing and painting and sculpture could come out naturally because the critical judgment had not known what to expect as the creative process was going on. We gave tools and techniques which could help the students sense the quality of things–visual and otherwise.

Corita

This chapter introduces some ways to put together your own works. These are personal-sized production methods using vegetables, innertubes, erasers, chopsticks, and old newspapers as tools for making books, walls, and staging theatrical productions. The more tools and techniques you have, the broader will be your making vocabulary.

The tools and techniques described in this chapter were ones often used in classes at I.H.C. But they were never ends in themselves. They were means to the end—the end being an assignment that came about because the Sisters had been asked to do an exhibit or lecture-demonstration, or because an article they had seen told about some obscure culture where it was the practice to make dancing dolls from palm fronds and peacock feathers. Then we would begin our research on every sort of dancing doll—why they were made, how they were made, and what kind of words and music should accompany them.

Rules in art classes were simple. Be neat, respect the technique and apply all the other "what ifs" you had come across in other classes. Technical demands were taken seriously. Ink must not seep through the edges of the silk-screen and spoil the borders of the prints, paper should be handled so it didn't get bent or creased. There was emphasis on turning out a professional quality product. How we would arrive at this was much less traditional than the final

product. The type for beautifully finished books was made from erasers, not lead. We were given tools and techniques not obviously related to art school exercises, or traditional tools were used in different ways. When we made these eraser stamps, we were so involved in trying not to slice our fingers (Corita charged us 75¢ per cut) or not smudging the image when we printed, that we couldn't worry about making things clever or pretty.

Lessen the prestige and the expectations of art and turn your endeavors into a good, solid, working job—like using hammer and nails. Thinking about making something great that should be admired for centuries is enough to freeze anybody. When Barbara Walters asked Sir Laurence Olivier how he wished to be remembered, he replied, *as a workman.* Walters was surprised and asked if he didn't want to be remembered as an actor or artist. *No,* said Olivier, *that doesn't matter. Shakespeare was a workman, poets are workmen, God is a workman, and that is how I wish to be remembered.*

Follow the rules exactly unless you come up with something better. Always keep in mind a ruthless attachment to quality without sentimentality; true feeling and power will be there instead. Workmen in ancient Egypt dealt with one stone at a time—with its placement and relationship to the previous stone—and were not encumbered with the immortality of the finished work.

WAYS OF DRAWING

Toothpicks

Sticks from the garden

Both ends of a feather

Chopsticks

An eraser on the end of pencil

Toothbrush

Various ways of drawing appear throughout the book in the context of other chapters. Be an inventor and find your own tools and techniques. Suggestions below are starting places, never the only ways.

Draw the area around the shape of the object instead of the object itself.

Hold long sticks at the very top and draw on the floor.

Draw upside down, from right to left (or left to right). Draw from the bottom up or from the top down.

Use a broom dipped in paint (both ends) for large projects, i.e., walls, etc.

Draw very slowly, paying attention to details. Let the drawing grow a section at a time and consider the whole later when the paper is full.

Use continuous lines—not little, hesitant, brushy lines (sketching).

Draw from projected slides and movies in the dark.

Draw with your opposite hand—left if right-handed and vice versa.

Do contour drawings. (See chapter one, *Looking*.)

assignment

Another way to draw that will help you relax about the outcome is called monoprint. For this you will need a piece of glass about twelve inches square, a tube of block printing ink–make sure it is oil-based–and a brayer (a roller used to press paper evenly against inked surfaces–available in art supply stores). Squeeze about an inch of ink onto a small dish. Dip your drawing tool in the ink–be generous. The drawing tool can be a chopstick for thick lines, or a barbecue skewer for thin ones. Brushes are possible, but difficult to use. Draw on the glass (working from a source). When the drawing is complete, carefully place a piece of paper over it and gently rub it with the brayer. If the ink is very thick, the lines will spread. (Thin the ink with mineral spirits for a different kind of look.) Be careful not to wiggle the paper or the picture will smear. Carefully lift the paper and put it aside to dry. When the ink is dry, the picture can be colored with water-based ink and the oil-based ink will resist the water-color. This way of drawing is messy and a lot of fun. The result is always a surprise.

WORDS ARE PICTURES

Corita says that she has never been able to distinguish between printing and drawing. Each is concerned with what form things should assume and which spaces they should occupy on a page. In Asia and the Middle East, as well as in early examples of Western manuscript painting, the words and painting together make the whole picture.

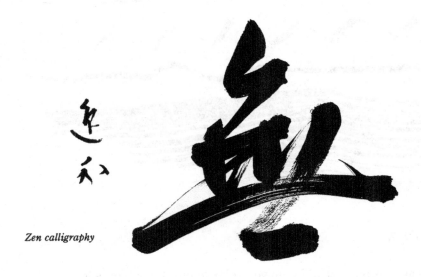

Zen calligraphy

graffiti in West Los Angeles

serigraph by Corita

Turkish calligraphy

left: constructed letter

opposite page: Two alphabets which we used at IHC–stick printing, done with a barbecue skewer and drawn Roman, done with a pen. These letters were drawn, care being given to the relationship of shapes and lines, without the use of straight-edge or other technical aids.

Some general rules about printing:

Ascenders and descenders should not be longer than the body of the letter.

Letters within words should be as close together as possible (without touching) except for verticals like *l* and *i,* which need slightly more space around them because they take up less space and can get lost.

Lines of printing should be far enough apart so they read as ribbons and the ascenders and descenders don't touch.

Never use guidelines for stick or drawn Roman printing–these are drawn letters, not constructed letters.

Spacing is the same for stick printing as for drawn Roman letters.

Vertical parts of stick printing should be slightly bent.

stick printing
abcdefghijklmn
opqrstuvwxyz

there are a great many
good pieces still to be
composed in the key
of c major.

arnold schoenberg

Drawn Roman

Even if you are on the right track,
you will still get run over
if you just sit there.

Will Rogers

Always choose an excellent example of the kind of printing you are doing and work from it. Classic and simple is better than fancy and new.

Here are some examples of good alphabets.

AMERICAN UNCIAL

ABCDEFGHIJKLMN
OPQRSTUVWXYZ
abcdefghijklmnopqrstuvwxyz

Life is a picnic on a precipice.
W.H. Auden

TRUMP MEDIEVAL BOLD

**ABCDEFGHIJKLMN
OPQRSTUVWXYZ&
abcdefghijklmnopqrstuvwxyz**

**Time exists solely to keep everything from happening at once.
Shanghai Fortune Cookie**

CASLON ROMAN

ABCDEFGHIJKLMN
OPQRSTUVWXYZ&
abcdefghijklmnopqrstuvwxyz

The messenger cannot rest until the message has been delivered.
Joseph Conrad

On the facing page, you can see the difference the tool makes. The all cap alphabet was done with a brush, the amen alphabet with a felt-tip pen, and the lower case, stick printed words at the bottom were done with the point of a wooden barbecue skewer.

ALL CAPS

YOU CAN LEAD
A HORSE TO WATER
BUT A PENCIL
MUST BE LEAD.
STAN LAUREL

amen ALPHABET

so called because only a-m-e-n
are lower case. all letters are
the same height. this is a
monalphabet.

DEAR GOD, I am a GREAT SINNER
AND DO NOT DESERVE HEAVEN.
JUST LET me STAY RIGHT HERE.
andres segovia

all lower case - stick printing

using a stick rather than a pen makes interesting
differences in letter thickness and since there is less
control of the tool, letters are more lively.

better to slip with the foot
than the tongue.
charlie chan

Old-style typefaces are based on calligraphy and lapidary (inscribed) forms. Tools and materials influenced the character of the letter–whether it was pen, brush, or chisel. In modern typography the form is again influenced by the tools used. Engraving on metal lends itself to forms which look mechanical and are far removed from calligraphy.

assignment

Letter a poem (or other words you like) in the following styles:

Drawn Roman–using one of the typefaces shown on page 130 as your example.

Stick printing–using the examples shown.

MAKING STAMPS

Almost anything is a stamp. Leaves and the sawed-off ends of bamboo make beautiful prints. Use a stamp pad from the stationery store. Potatoes, carrots, and other root vegetables can be used. Cut a potato the long way and stamp the whole surface, using either a stamp pad or water-based paint. You will be able to see what the surface is like and where there are high and low spots. Keep them in mind when you carve the design. Wash off the paint or ink and carve your design carefully with a dull knife. Use the same process for all the vegetables.

Innertubes make very nice prints and last longer than vegetables. Cut away what you don't want to print and glue (with rubber cement) the shape you want to print on a firm surface, such as a block of wood or piece of firm cardboard. If you use cardboard, be sure it is heavy, firm, and thick. Always remember when you are working with these printing methods that the image is reversed. If you want a person to have a dark eye you must leave the area of the eye intact; that area will contact the ink and print dark.

Rubber stamp alphabets made from erasers are tools for printing and for investigating shape and form. When you choose your model alphabet to carve, make it simple. Pleasing lines are important, but the purpose of the letter is to communicate. Letters with much ornamentation are often hard to read.

Eberhard-Faber Rubclean erasers (green) are excellent for carving.

1. Choose the alphabet to be made and take it to a copy center. Make prints of everything you want to carve.

2. Rub the letters onto the eraser using a dull tool–a scissors handle is perfect. Be sure the paper and the eraser are held together firmly. Don't wiggle or the images will be indistinct. The letter will be a mirror image on the eraser.

mirror-image letter

3. With a number 11 X-acto blade, (always pointed away from you in case it slips) slowly and very carefully carve around the letter about inch deep. The incision must be straight down–cuts made at angles undercut the image, making it print unevenly and break off. Gently peel away the rubber around the letter shapes. Cut the eraser down to a rectangle the size of the letter so you have a spacing guide.

the carved eraser

print of the finished stamp

If you don't have a copy machine handy, trace the letter onto a piece of paper with a very soft pencil. Turn over the tracing and place it on the eraser, rubbing the image with the scissors handle. Be careful not to smear the outline as you carve it.

What power: your own printed word.

A wonderful stamp can be made from the plastic trays that hold prepackaged meats in the supermarket. Cut out a piece of the plastic that has no patterns or indentations. The only tool required is a ballpoint pen, with which you draw directly on the surface with enough pressure to indent your design. A stamp pad may be used to ink the surface, or if you want opaque color, block printing ink works well. The stamps are quite fragile, and if you want to preserve them, glue them to a block of wood. That also makes them easier to grasp when you are printing. These humble plastic stamps have a wonderful look, are easy enough for your children to make, and cost nothing.

Good sources for stamp designs include:

Textile patterns: Basic shapes can be interchanged to make new designs and overall patterns. The only limit is the size of the eraser. Continuous patterns can be made by combining stamps. Block printers in India print hundreds of yards of fabric with intricate color changes using blocks smaller than your eraser.

Stencil designs: Craftsmen from Japan and North Africa, and those who work in the Pennsylvania Dutch tradition, all use stencils as an important element in their designs for houses, fabrics, and the like.

Rugs woven in China, Persia, the Caucasus, and Afghanistan.

Use as source anything you like to look at in rows or groups: trees, flowers, fruit, angels, animals, people, and so on.

Dover Archive Series has compilations of copyright-free designs that make good sources for stamp carving. The design sources on the opposite page are Ancient Egyptian, Japanese, Persian, Chinese, and early medieval from Britain.

assignment

After carefully looking at many folk art sources, decide on three designs you think are suited for transferring to the surface of an eraser. When they are made, stamp at least five different combinations to make ribbon patterns or all-over patterns.

ducks made from carved eraser

assignment

Here are eight different uses for your stamps. Choose three of them.

Make your own gift wrap for Christmas, birthdays, or weddings.

Design your personal logo and print your own cards and stationery.

Write a letter to a friend using an alphabet you have made.

Make a set of greeting cards.

Use water-based textile ink on your stamps to decorate fabric for use as clothing.

Decorate your kitchen cupboards with designs and words about food. Use acrylic or oil-base paint.

Make a set of personalized book covers.

Embellish a textbook or otherwise unadorned book.

print from stamp made from plastic tray

print of a leaf made by pressing the leaf directly on a rubber stamp pad, then on paper

Folk art design is an old thing. Eraser design is a new thing. Each must be judged as itself and never as the other. Don't feel disappointed if your stamp is not the same as the original. It is a different thing and has its own life and use.

assignment

Choose your three favorite alphabets as models and make a rubber stamp set of each of these. Think of them as treasures.

Make stamps of the same flower (source) using each of the following: a potato, a plastic tray, an innertube, and an eraser. See how they differ. Make a list of five qualities unique to each. Make a list of five uses for each type of stamp.

HOW TO USE WHITE GLUE

Open the bottle with a straight pin. Make only one hole–the opening should be no larger than the pin.

Lay a thin strip of glue along the very edge of the paper.

Before attaching anything to this piece of paper, blot it with some scratch paper.

After you have joined two surfaces together with the glue, cover them with a clean piece of paper and rub the surface with your thumbnail.

If you need to cover the entire surface with glue, as in some forms of bookmaking, apply the glue in a back and forth manner to the paper and use a piece of cardboard with a straight bottom surface as a squeegee. When you have spread the glue evenly, cover and rub as above.

ESTABLISHING PAPER GRAIN (HOW TO TEAR AND FOLD PAPER)

For collage material, tear quickly so that you don't get too fussy about the shape or the subject matter. Determine the grain of the paper by folding and creasing it in both directions (horizontally and vertically). The crease against the grain will be rough and irregular–the crease following the grain, smooth. Another way to determine grain is by tearing the piece of paper. If the strip comes out long and straight, without rough edges, you are tearing with the grain. Well torn paper looks as if it grew that way.

For making books or other constructions, use a good quality paper with a high rag content. Always fold with the grain.

BOOKMAKING

Now that you have printing and typesetting devices, make a book.
There are many fine blank books available, but to make your own is
most rewarding.

1. To make a book 5 inches high by 9 inches wide, fold in half several pieces of
 paper 5 x 18 inches and stitch them
together down the center using the
baste stitch on a sewing machine.
Staples may also be used. Staple on the
outside seam making sure to pound
flat any sharp edges.

2. After the paper is stitched you will see that the edges of the outside sheets
are shorter. Trim the edges so they are even.

3. To make the cover for your book, cut two pieces of heavy paper or
cardboard 5½ x 9½ inches (slightly larger than the book pages).

4. Join the book covers by gluing a strip of cloth 2 x 5½ inches the length of
 the 5½ inch side to each piece of
cardboard. Position the cardboard
pieces about ¼ inch apart. Glue pieces
of paper to the inside of the cover to
hide the edges of the cloth.

5. While the cover is still open and flat (with the inside facing up), open the
 book pages to the center-fold and lay
them on top of the cover, allowing an
even border of the cover to show
around the pages.

6. Stitch or staple the pages to the cloth binding.

ANOTHER KIND OF BINDING
FOR A THICKER, STURDIER BOOK

1. For a book of the same size (5 x 9 inches), but thicker and stronger, cut 50 sheets of paper 5 x 11 inches. Make sure that the grain of the paper runs vertically, from top to bottom of the 5 inch dimension. Measure 2 inches from the end of each page and draw a line from top to bottom (5 inches) with a ruler.

2. With the dull side of a scissors point, press firmly and score along the pencil line. Fold the paper along the line, with the score on the outside. Press along the fold with the scissors point. Fold in the opposite direction and press again. Repeat the entire pressing-folding process one more time.

3. Join the 2-inch sections of each page by spreading a thin coat of white glue over the surface, using the cardboard squeegee to make an even coating. Place a clean sheet of paper over the glued tabs and rub firmly to make sure they are joined securely and there are no bubbles. Continue this process until all the pages are glued. Cover both sides with a clean piece of paper, put them between two flat pieces of wood and place them in a vise overnight. If you have no vise, use a stack of heavy books.

4. For the cover, cut two pieces of cardboard 9 1/2 x 5 1/2 and two pieces 2 1/2 x 5 1/2. Join the 2 1/2 inch piece to the 9 1/2 inch piece on the 5 1/2 inch side by gluing a strip of strong cloth between them. Leave enough cloth between the cardboard pieces to allow the larger section to fold back completely. Finish the inside by gluing a piece of paper (as with the first book) so the cloth edges don't show, or show beautifully.

5.

The scored ends of the paper will fold where the two cover sections have been joined by cloth. Glue the small sections of cardboard to the small ends of the joined pages and weight them overnight.

This makes a beautiful, long-lasting book.

JAPANESE FOLDING BOOKS

These books offer terrific surprises in the way they move back and forth, revealing small sections, combinations of unrelated material, or the whole contents at once. To get the feel of their mystery, play with one for a while.

1.

To make a folding book, cut three strips of paper 2 inches wide and 11 inches long. Fold each piece in half (along the grain) and then in half again.

2.

Cut and remove all but ¼ inch of one piece, making a small tab. Use that as the middle section. Glue the tab to the first section of the next strip until the three sections are joined. When they are dry, refold the strip so they make an accordion fold. Close the book so it makes a rectangular shape.

3.

For the cover cut two pieces of cardboard ¼ inch larger all around than the folded book. Glue a piece of cardboard to the top page.

4.

Open and unfold the book, checking for bonding. Fold it up again so the glued cardboard cover is on top.

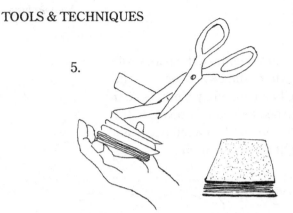

5.

Turn the book over in your hand so that the glued cardboard cover is on the bottom. Cut off the end page (rectangle) at the crease and glue the next page to the second cardboard cover. It is a little tricky to get the back on correctly, so follow these instructions exactly.

The words that go into the book are also part of the visual message. Pay attention to how they sit on each page and to the space around each letter and word–to the relationship to other visual material on the page. See how the whole page looks, separately and in relation to the next page.

Books can be made from many materials. An ancient type of religious book made of palm leaves is still created in the state of Orissa in India (where it is called *pothī*) and in Bali (*lontar*). Designs are pressed into a waxed palm leaf with a sharp stylus and the incision is filled with ink or charcoal dust. When the leaf is wiped clean, the recessed lines remain dark. The *pothī* is made of strips of palm leaf stitched together with brightly colored string. Lively floral motifs are cut from the leaves, making a fretwork, which is brightly painted. Colored papers, sometimes metallic, are used for background, showing through the cut-out designs. Hinged to this are delicately engraved half-circles–also of palm leaf–which contain the central text and illustrations. When these flaps are lifted, new images are revealed. The *lontar* uses the whole surface of each palm leaf strip for the elaborate engraving. Although the *lontars* made today usually show only engraving, photos of old books show the engravings stained with translucent color. *Lontar* pages are loosely strung together and may be viewed or turned separately.

lontar

pothī

142

FLIP (MOVIE) BOOKS, POP-UP BOOKS, BOOKS WITH DIVIDED PAGES & SEE-THROUGH BOOKS

Keep looking for books that are made or bound in different ways. Look for books that do more than just sit there—books that invite you to play.

Movie books are not called that because they are about movies, but because they enable you to make your own moving picture. Sometimes they are called flip books. They are bound in the simplest way and each page has a picture. (A picture is anything you put on the page.) They should be no larger than four inches square to work best. Grasp the bound side with one hand and flip the pages quickly—as if you were shuffling cards. The rapid succession of images will make a movie—a series of frames with continuity.

Pop-up books are a delight. Simple ones can be made using just the centerfold. Buy a pop-up book (often found in the children's section at your bookstore) and carefully dismantle it to see how the folds and cuts are made. You can adapt the engineering to your own project.

Delightful books can be made by cutting windows (shapes) in pages so you can see through to the next page (and the next). Use transparent papers or thin plastics to change color and texture. Make a book with the pages cut in half (or thirds, or quarters) so you can combine images to make new pages.

papier-mâché skull

HOW TO MAKE PAPIER-MÂCHÉ

Mix a half pound of wheat paste–the powdered kind used for wallpaper paste–in a gallon of warm water. Add the powder very slowly to the water, stirring as you add, until the mixture is the consistency of thick cream and there are no lumps.

Armatures can be made from balloons, stuffed paper bags tied into shapes with string, or crumpled newspapers shaped with tape or string. Chicken wire and cardboard are good for larger structures. Clay can be molded and covered with strips of paper dipped in the paste.

Tear newspapers into strips about two inches wide (smaller if you are working on something small, larger for big pieces). The strips can be as long as is comfortable. Submerge the strips into the paste and pull them out, sliding them between the second and third fingers–making a squeegee with fingers, to remove excess paste. Smooth the strips over the frame, alternating directions for strength. Make absolutely sure there are no air bubbles, lumps, or wrinkles between the layers. Press each strip down and rub it so it blends with the piece underneath. For an even finish and additional strength, use strips of cloth rather than paper.

Be sure your object is completely dry before painting. Small pieces dry nicely in an oven heated to 200 degrees. You can dry pieces in the sun or against a heater, but be sure to turn them so they dry on all sides. If the piece isn't thoroughly dry all the way through, it will get moldy and the paint will peel.

Before painting, sand and apply gesso–a plaster of Paris available at any art store. Sand and gesso as many times as your life permits, then you can paint. If you use water-color or tempera, the piece will need to be sealed. You can lacquer and sand until it feels like silk. Then rub it with a piece of silk until the finish is like that of a Japanese temple sculpture (often made of papier-mâché and finished with thousands of layers of lacquer).

Perhaps silky papier-mâché isn't important or appropriate to your project. The powerful shapes of giant puppets are made stronger by a rough texture, but they take no less effort or care to make. I once saw a beautiful Noah's Ark where Kleenex dipped in a thick paste of white glue and wheat paste made rough coats for sheep and camels. The important thing is caring about making something well.

masks from (left to right) Thailand, United States, and Africa

USES FOR PAPIER-MÂCHÉ

Masks: Simple armatures can be made from balloons or paper bags stuffed with newspaper. Masks can also be flat and tied around the head by a string. Masks don't need to cover the whole face: large eye holes can give life to the mask. Or cover the face to just below the nose, and let the mouth speak for itself. A mask can also be just a painted paper bag.

Environments: Make a bigger-than-life sculpture. In India giant papier-mâché figures–often more than forty feet high–are set on fire at the Desserha festival.

Puppets: Heads, bodies, and limbs–as well as scenery–can be made from papier-mâché. They can be put together with glued pieces of cloth so that the joints are flexible.

PUPPETS

A puppet play is a wonderful vehicle for combining visual material, music, drama, magic, and technical skills, and provides a great time for performers and audience alike. When the puppets leave the stage to walk or fly through the audience, the willing suspension of disbelief may be at its highest peak. Though puppets are usually made to resemble human beings or other earthly creatures, the essence of a puppet play is that it can and should be larger than life. The great Japanese dramatist, Chikamatsu Monzaemon (1653-1725), who wrote for the Bunraku puppet theater, gives an example:

> On the occasion of a festival, the snow had fallen heavily and piled up. An order was given to a guard to clear away the snow from an orange tree. When this was done, the pine next to it, resentful that its boughs were still bent with snow, recoiled its branches.

Chikamatsu said that this short passage from *The Tales of Genji* taught him how to put life into his plays. The image of the inanimate tree shaking its branches in rage represented the unique quality of the puppet theater. Chikamatsu cautions that the great freedom of the puppet theater is lost when we try to duplicate life. It is in the stylization of essential characteristics and the transcendence of the world we know that the mind is delighted and the emotions are touched.

The Bunraku is perhaps the most complex of all puppet productions. The chief characters of the Bunraku puppets are nearly human size and are operated by three men. The heads and hands of the puppets are carved and lacquered. Human-hair wigs and elegant brocades and silks make them figures of exquisite refinement.

The Snake Theater of Chris Hardman is a powerful contemporary statement of the art of puppetry. Puppets are up to twenty feet tall with great, craggy faces, which when viewed from close up, look rough and have exaggerated features, the antithesis of the Bunraku. Viewed from a distance, the faces are fine character projections.

Puppets are to say and do what someone won't let you—or you can't.
Tina Steward, age 9

Children pick up their forks and spoons and carry on conversations with them. Did you ever make your own shadow plays on the bedroom wall? The shadows cast by your fingers made ducks, elephants, and flying birds. Puppets are used as educational tools, and as a means to unlock deep problems in disturbed children. In Asia, the puppeteer is often a priest, who uses the puppets as a means to teach the great religious epics and their messages. In Indonesia, the *dalang* (puppeteer) is a medium for communicating with one's ancestors.

hand puppet

finger puppets

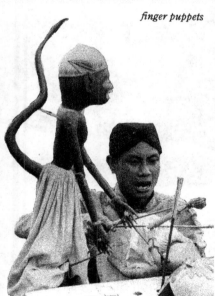

*Wayang Golek,
Javanese rod puppet*

A *hand puppet* (glove puppet) is a figure which is slipped over the puppeteer's hand. He may use various fingers to control the figure, but generally the forefinger fits into the head of the puppet, the thumb controls one hand, and the third finger controls the other. Punch and Judy are examples of hand puppets.

Finger puppets have heads made of balsa wood papier-mâché, folded paper, or paper masks, or faces can be painted directly on the finger.

A *rod puppet* is a figure worked either from above or below with wooden, bone, or metal rods. It usually has an articulated head, arms, and legs. If it is worked from above, a rod may be fitted through the head of the puppet and mounted to the body, while two other rods are used to control the arms. The standing puppeteer is usually concealed by a cloth or scenery.

If the rod puppet is worked from beneath, the puppeteer usually squats on the ground. The front of the stage usually conceals the puppeteer from the audience. The puppets are held above his head; he holds a rod inside the body of the figure which goes to the head to control both head and body movements. Sometimes the head is attached to a narrow rod which passes through a hollow tube, often bamboo, so that head and body movements can be controlled separately. Two other rods, worked somewhat like chopsticks, are used to control the arms.

Shadow puppets are made of wood, metal, paper, or leather, cut out to form the parts of the body and head. They are often hinged together with string, wire, paper fasteners, or leather thongs and are worked by rods attached to the upper part of the body and the wrists. Shadow puppets are generally used at night. A screen of translucent cloth is illuminated from the performer's side and the puppets are manipulated between the light and the screen. The audience, on the opposite side of the screen, sees articulated figures, either silhouettes or colored images. In Java, Bali, and other parts of Asia, the shadow play theater is often performed all night. The light source is a kerosene lamp, flickering in the wind, adding another dimension of movement to the elegant puppet shadows.

Javanese shadow puppet

String puppets (marionettes) are worked from above. The usual stringing of a marionette includes two strings to the head, one to each shoulder (which supports the body), one to the back which permits bending forward, and one to each hand and leg to control the limbs. There are countless variations to this basic stringing technique.

marionettes

We can combine many kinds of puppets–or make up new ones which will emphasize the essence of each character. One of Corita's favorite puppet shows used narration by Lord Buckley–a night-club entertainer who in the language of jazz, told some old stories in new ways. The show was based on Buckley's piece called *The Nazz,* in which he describes several episodes in the life of Jesus–with fervor, grace, and love.

Christ was represented with two different images. The active image was a wheel made of a photo-collage of faces (real people as well as sculpture and other art), mounted on a large cardboard circle. A hole was made in the center and a nail put through and pounded into a strong dowel. We could spin that wheel—the faces blurred, finally slowing to focus. When the image of Christ accompanied descriptive material or passive narration, we used a photo of Rudolph Valentino dressed in an exotic Scheherazade-type costume, cut out and mounted so it could stand. A small ring of wire attached to his hand held a fresh rose for every performance. He was very beautiful and contemplative.

Episodes in the narrative included the cure of the lame man, walking on water, and the miracle of the loaves and fishes. When the Nazz told his followers to lift their arms to the heavens, small cut-out figures, whose arms were jointed at the shoulder and strung to a stick, obediently raised their arms and were rewarded with a loaf of *Wonder* bread and a large rubber fish.

assignment

Produce your own puppet play. Start by choosing a story and making it into scenes, then dialogue. Research the period in history to establish the locale and customs for your play.

Determine the most important characteristics of each puppet and how best to represent and project them by making a list of the roles to be portrayed by each character. Use different kinds of puppets—marionettes, rod, hand, or shadow puppets—to establish the essence of each role. In Rajasthan, the servant puppets are constructed to sweep or bow, drums and drummers are in one piece, and the arms of warriors become swords rather than hands. Use traditional puppets as sources for new forms.

Choose music, not just for background, but to enhance and underline the drama. Organize other sound effects and practice making different voices and ways of speaking for each puppet.

Have at least three different things that move (waves, clouds, rising suns or setting moons) for your stage scenery. Look at books on Renaissance theater for ideas on tremendous special effects.

Your stage contour will be determined by the kinds of puppets you use. It can be as elaborate as the Bunraku or as simple as the piece of ribbon, strung between two poles, used for daytime puppet performances in Bali. Plan your lighting to fit your stage.

Rajasthan puppets

The last thing done by the puppeteer when he makes the puppet is to put the eyes on—giving the puppet life.

A puppet play is a kind of summary for trying all the tools and techniques talked about in this chapter—and an opportunity to investigate new ways. It gives you a chance to be on stage—to sing or clown without being seen. Best of all, a puppet play makes it possible for you to defy gravity, move mountains, make miracles, and live happily ever after.

WORK

> Only where love and need are one,
> And the work is play for mortal stakes,
> Is the deed ever really done
> For Heaven and the future's sakes.

Robert Frost

Work is often done by playing around. For example, when you set out to write something that must be finished and finely crafted, you can begin by playing around. Write anything that comes into your head or write about what you see around you or what happened yesterday. This is to get your feet wet; soon you may find yourself swimming in material pertinent to your piece. You then can start rearranging and rewriting. Letting yourself go free, playing around until something comes, is often very hard work.

Or it all seems too difficult—you are faced with a blank. Go to a movie, take a walk, read a book for fun. Sometimes these experiences will spark an idea or memory or thought so that the fun times prove to be marvelous resources-research. Was that free time or was it simply the early part of some work?

One way to start working is to put something, anything, on paper and then do it over and over. This can relax you and allow greater freedom because you are less critical (none

PLAY

moments when you are making and you are not conscious of thought or anything outside. After doing a piece over and over, it either comes to a satisfactory solution (who is ever totally pleased?) or you can spread all your attempts on the floor and choose the one with the most vitality. The choosing, too, is a combination of work and play. You are working to find a usable piece and yet you are, as the dictionary defines play: moving swiftly, erratically, intermittently; darting to and fro, fluttering, vibrating. *You've done the work—now comes the pleasure of choosing. And the choosing is also a bit of work.*

It is the way of disappointment to expect too much, or only to work or only to play. So you have to lower your expectations, hope for the best and work and play. The dictionary definitions of work and play have much in common, as if the person defining these words could not pull them apart to be two separate things.

Corita

has to be the best picture ever made). Playing allows you to slip into working from which you can easily slip back into playing. Then come those marvelous and rewarding

155

One dictionary definition of work is: *to make, effect, or bring into being.* The same dictionary defines play: *to bring about, work or effect.*

Play is a way of working and work is a way of playing. Our best times are when working and playing are the same.

Sanganeer is the name of a village about fifteen miles from the pink palaces of Jaipur in the Indian state of Rajasthan. For more than 250 years the people of this village have excelled in the art of block printing–in which a design is carved in wood and stamped in color on a piece of fabric.

samples of textile prints *printing block*

The name *Sanganeer* means *the meeting place of seven rivers*. A great river had once nearly encircled the village, but now it exists only in the rainy season. We went to see where the river had been. We walked down a wide, unpaved street that was lined with architectural remnants of the great civilizations that had lived there. It was a quiet afternoon and shadows emphasized the delicate carvings on the Jain temple. We were greeted by a few children carrying stacks of printed cloth on their heads, their bare feet making no sound on the dusty ground. Gradually I became aware of the sound of drums, and then, singing. But these were not drums I had ever heard before. They were not the sharp-sounding *naggaras,* or *tabla;* they were not the deep-booming *dholak.* The sounds were softer, muffled.

The drums I had heard was the sound of the blocks being applied to the cloth, first with a sharp whack and then a softer thump of the side of the printer's fist on the block. The percussive printing rhythmically accompanied singing, as would a drum. I asked if this was a special day and was told (through three translators) that *Yes, the sun had come up again.* I asked if the music always accompanied the work, and it was obvious they hadn't understood. I phrased it differently, *Do you always sing when you print? Do you understand what I am asking?* There was a huddle of printers. *Yes,* they said they had understood my words but *No,* they couldn't answer the question because the two things were the same.

157

dyed cloth drying in the sun at Sanganeer *block printing on fabric*

Sound is carried enormous distances in the thin desert air of Rajasthan. The music of the well can be heard outside the village gate. The well is the center of life. The cloth, before and after printing, is brought to the well to be processed–first soaked in a mixture of goat dung, soda, ash, sesame oil, and water to make the cloth accept the dyes. Finished pieces are stretched flat and kept damp, to cure in the hot sun. Sanganeer cloth is famous for its rich color, and craftsmen say it is because of the water, which has a high chemical content, and the power of the sun here. Seventeenth-century journals refer to the best water for dyeing as being *hard*–a term we still use today. People come to bathe at the well; animals too, are washed there. Clothes are laundered, laid out to dry, and people gather to discuss the day's events. I heard different songs there, different rhythms. There was the whoosh and thump of fabrics pounded against the sides of the pool–a different beat than the printers, but also rhythmic and accompanied with singing or other vocalization.

Bright strips of cloth were hung on every available post and rail, stretched on the ground, and hung over lines in courtyards. Whether in brilliant sun, or the soft light at *the hour of cowdust,* color permeated our world and made it richer and more beautiful than I had ever seen it. There was music everywhere–the singing, the drumming, and the sound of bells on the ankles of women and around the necks of cows and camels.

PLORK

We tend to think of play as abstract, without a goal, and somewhat irresponsible–
while work suggests a goal, is specific and honorable. Because of this, play
can be more challenging–even though we have been taught to perceive work as
that challenge. We need a third word–one which combines the two concepts and
allows us to recognize them together as one responsible act necessary for human
advancement. We combine the abstract and the concrete, the joy and the labor.
That word would represent the ecstasy we feel when work and play are one.

playing with bean sprouts

GETTING STARTED

Here's how it works. If you want to make a special birthday card, you could start by taking a pile of pictures and a pile of words–poems or books with your favorite passages underlined–and play the matching game. The words might spark the image or the image might spark the words. This process of combining words and images will begin the greater process that brings the non-specific into focus. The person for whom you are finding expression will be reflected in this pile.

Sometimes everything falls into place–but when it doesn't, try turning the image upside down. Often the most unsuccessful picture when seen from this fresh view will be exactly right. If this doesn't work–simply tear up everything and take sections and rearrange them. A random piece, not inhibited by the prior spatial context, can become a marvelous thing you could never have arrived at if you thought there was only one way to put words and pictures together–one way to put paint on paper.

If your words and pictures still seem far apart, use a finder. The finder will take small, specific areas out of context and perhaps get rid of the parts you don't like. Then you will be in a very right place.

Sometimes we can work and work at something–a drawing, card, printing or words–and it will all seem terrible; and the very next day–perhaps with the addition of some small thing which now seems quite obvious–the piece will seem finished. It's a matter of keeping on. You will have loosened up and gotten little hints from the previous tries, and things begin to flow together. You will know when it is time to stop playing around.

In the work/play process just described, you are finding new ideas and images in what has already been collected or done. If someone were to witness your sifting, stacking, and tearing of paper–the messy house, the late dinner–they might purse their lips in disapproval and think you were just playing around. Well, yes, but it was really very hard work.

sand castle

Watch a child
when she is drawing or painting.
You will see a worried look on her face
—a look of intense concentration.
Is she working or playing?

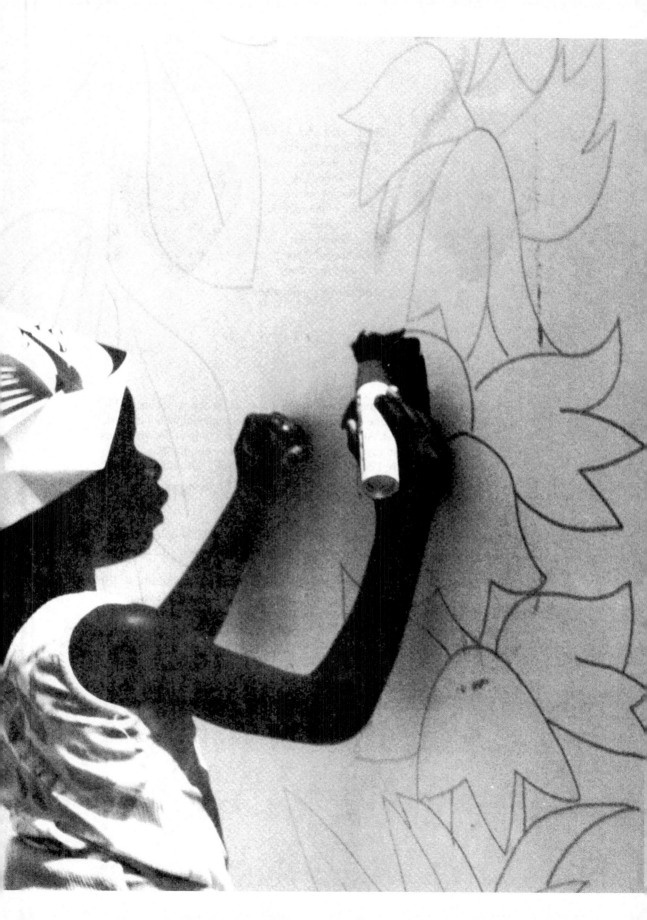

Come to the edge, he said.
Come to the edge,
he said.
They said:
We are afraid.
Come to the edge, he
said.
They came.
He pushed them . . .
and they flew.

Guillaume Apollinaire

GETTING UNSTUCK

For a voyage to the destination, whatever it may be, is also a voyage inside oneself, even as a cyclone carries along with it the center in which it must ultimately come to rest. At these moments I think not only of the distances I have travelled within myself–without friend or ship–but of the long way I have yet to go before I come home within myself and within the journey.

Laurens van der Post

Sometimes when it's hard to start working, one can start playing instead. Close your eyes and put your finger on a word in the dictionary or the thesaurus.

It won't matter what the project is; the important thing is to get out of the stall position before you crash. On one occasion, my word was *backwater.*

I decided to stir the water a little and looked up what flowers grow in swamps. Then I cut a hundred flower pictures. I couldn't find enough varieties of flowers that grow in swamps–any would do. The point was to have a hundred flower pictures. I made a hundred small paintings–each taking no more than three minutes. I looked in the thesaurus again, this time under *flower:*

nosegay, posy, bouquet, boutonniere, spray, garland,
festoon, chaplet, blossom, bloom, unfolding, full bloom.

The market near our house has a great selection of cardboard boxes. I filled my car with twenty of the best, smallest ones I could find, trying to make them uniform in size. Friends were invited for dinner, and I promised them the immediate flowering of a garden before their eyes. I had stacked thirty books–from poetry and art to popular mechanics–on the living room floor to be used as sources. Another stack contained the drawings I had made and old magazines that could be cut up for collage. We played the matching game of words and images and glued or painted the results on the boxes. Most of the words and images had nothing to do with flowers at all–but of the things flowers might remind us of. We did make a tall flowering garden by stacking the boxes. It was taken apart later, but the important thing was that it had been made. We got out of the backwater–we started something.

GAMES

Children in ancient Greece had their skipping ropes, hoops, and hobby horses, and 4,500 years ago in Sumeria there was a popular board game analogous to checkers. The need to play games is timeless and universal–and in spite of centuries of attempts to regard them as the pastimes of children, adults too, find in games a release and creativity that can accelerate solutions to other problems. The divergent thinking required in a chess game is useful at home or work where we may be threatened with other kinds of checkmate.

Card games and board games (indoor games) usually combine skill and chance. All have rules and consequences for breaking them. There are prescribed ways of advancing to a set goal. Often there are limitations inherent in the characters or symbols which are the instrument of play. Games such as *Scrabble* and *Trivial Pursuit* rely on information not directly connected with the game board or playing pieces.

assignment

Make three games. Remember Robert Frost's advice that we don't need to make new worlds (games), but to recreate the world we have.

Make a card game. Perhaps it's time to revise *Old Maid.*

Make one of the games a word game–a personal *Trivial Pursuit* or maybe a dimensional *Scrabble* using stacked cardboard boxes.

One of the games should be a board game. I made two chess sets. One was of barnyard creatures. That came about when my son said he liked the game–but not the feudal images. I made the second, called *Denizens of the Deep,* because I couldn't resist the idea of using prawns.

papier-mâché rattles

TOYS

If you have ever tried to pry an enthusiastic father away from a model train so the kids can have a turn, you understand that toys, like games, are as compelling to adults as to children. Whether moving or stationary, Dresden or folk, combining music and light or the yielding silence of a teddy bear, toys have always engaged human creative skills and devotion. Perhaps there has been no inventor in the history of toys equal to Hero of Alexandria, who lived during the reign of Ptolemy VII (about 150 BC). Diagrams of his work appear in his book *Epeiritalia,* and centuries later (1891) in C.W. Cook's *Automata Old and New.* Hero invented an automaton consisting of four small birds who sing until a watching owl turns in their direction; a priest and priestess who pour libations on the sacrifice when the altar fire is lit; and an animated Hercules who shoots his arrow at a hissing dragon. Though toys have become more technically sophisticated, Hero's automata, using water, air, heat, sand and stones, have hardly been surpassed in their ability to enchant.

The simplest toys–a spinning top or the amazingly realistic movement of a snake made of jointed bamboo–have a mesmerizing power to make us repeat the movements time and again. Leverage toys show us performing acrobats and cats climbing poles. Tumblers, with lead weighted bases, perform somersaults and always land upright. Pull toys use a series of rollers connected by uneven axles to make the duck wings flap.

assignment

Make a toy. Make it something you want to play with–just to please you.

*characters from the barnyard chess set
Sheep are pawns, donkeys are
bishops, pigs are knights.*

. . . to turn, to turn,
will be my delight.
Til by turning, turning,
we'll come 'round right.

Simple Gifts,
a Shaker hymn

Celtic design from the royal burial at Sutton Hoo

KEEPING ON KEEPING ON

Every day we are confronted by situations or problems to be solved that are new to our experience. We try to resolve these matters by relying on what we already know–on traditional or personal knowledge–but sometimes that isn't enough. If we try to make old solutions fit new problems it can be like wearing a pair of too-tight shoes; we can walk but we can't dance. Keep the momentum. Play with materials, experiment, go up a hundred blind alleys and you will find marvelous things there. No work is bad–it's only unfinished.

Fairy and folk tales (especially Celtic stories) are terrific examples of the advice given in the Shaker hymn above. We are usually aware of the goal, and the excitement comes in the ingenuity of the clever hero, who against all odds defeats wicked kings, demons, or mischievous rivals in order to accomplish it. Because there are so many obstacles to the resolution of the goal, he deals with one step at a time–otherwise he might be overwhelmed by the enormity of the task. Though it may seem that decisions are pure improvisation, they

frequently are based on some ancient or obscure piece of knowledge, stored away, but remembered when needed. (We all can do this when we are faced with the need for new solutions.) These stories make work into play, darkness into light, and tell us we do have choices and the power to change things.

Japanese folk tales are masterpieces of surprise. My favorite, *A Leak in an Old House,* tells of an old man and an old woman trying to get to sleep on a rainy night, but the rain drips on their bed through a leak in the roof.

Truly a leak in an old house is worse than a tiger-wolf, says the old man. It just so happens that a tiger-wolf is lurking outside their window, and terrified when he hears there is something worse than he, runs to hide in the barn. A horse thief has also hidden there and when the tiger-wolf races in, mistakes him for a particularly fast and agile horse and leaps on his back. The tiger-wolf, thinking he has been mounted by a leak-in-an-old-house, runs howling down the road. When he stops abruptly at the edge of a steep ravine, the horse thief is thrown over his head and into the pit below–from which he cannot climb out. A group of kindly monkeys, out for an evening stroll, hear the cries of the thief, and make a monkey chain. Each holding the tail of the next monkey, they lower themselves into the ravine. As the thief begins to climb out, his weight proves to be too great and one by one, the tails of the monkeys begin to break off. The last line of the story tells us: *This is another story about how the monkeys' tails began to get short.*

A Leak in an Old House is a charming lesson in letting things happen–a great example of the delight to be found in blind alleys and surprise endings.

> *April*
> *the blue titmouse in the poplar.*
> *and what else?*
> *the poplar against the blue sky.*
> *and what else?*
> *water in the small blue leaf.*
> *and what else?*
> *the new petal in the rose.*
> *and what else?*
> *the new rose within my heart.*
> *and what else?*
> *and my heart within your own.*
>
> Juan Ramón Jiménez

Dr. Alois Schardt, one of the first members of the art department faculty at Immaculate Heart, told students how he helped a wealthy businessman to acquire a fine art collection.

Dr. Schardt was sitting in his office at the university one day when a man knocked on the door. He asked him to come in and recognized him as a businessman who had made a great fortune. The businessman told him he was there to ask his help in starting an art collection. Dr. Schardt said he would be glad to help and they made a date to go to a gallery.

Which should I buy? asked the businessman, and Dr. Schardt said he must choose for himself. *Just buy one and see how it goes,* he said.

The man chose a picture, bought it, and took it home. About two weeks later he called Dr. Schardt and said, *You know, I've been sitting here looking at this picture and I think there was another one I liked better.* Dr. Schardt answered, *Okay, we'll go back.*

The process was repeated many times. The man would buy a painting and take it home and look at it a while and then go back to the gallery to choose again. This went on for a long time.

Some of the paintings were kept and some returned or traded. Each time the businessman would have to choose. That businessman developed the most incredible taste and knowledge—with no formal lessons in art. He learned to play around, to listen to his own inner beliefs, and to act on them. Dr. Schardt believed we all have this ability in us and just need to develop it.

assignment

Acquire 500 findings–the picture made by the finder. One way to do this is to cut ten pages from a magazine, stack them neatly and cut them in half. Continue cutting and stacking until they are the desired size. A paper cutter makes this very fast and easy.

1. Make five stacks of findings–100 in each stack.

2. Set a timer for five minutes.

3. During this time sort one stack of 100 into two piles (favorite and less favorite). Choose quickly and allow your eyes, rather than your brain to make the choices.

4. Do the same for each of the remaining four stacks. (This will take twenty additional minutes.) You will now have ten stacks; five favorite, five less favorite.

5. Choose twenty findings from each of the five favorite stacks.

6. Combine these into one stack of 100.

7. From this group choose the ten you like best.

8. Choose one.

Glue this final selection to a clean white surface, larger than the picture. Be careful and respectful. Keep the borders clean and even. You will see how important and beautiful that small piece will become.

> *The trick is to have lots of ideas and throw away the bad ones.*
> Linus Pauling

sewing box
On the outside, Victorian
ladies are very proper,
but open the top—and see
what really goes on.

PLAYFUL WORKS OF ART

Nancy Jackson is a Southern California artist whose joyful work is infectious–makes me want to do something–to play, build, or paint. Every room in her house is testimony that art isn't separate from life. She is a fine painter whose works reflect her humor and bright spirit, but it is her furniture and other household accouterments (usually made from pieces salvaged from trash piles) that are my favorites. The *Theatrum Vulgarium* (her T.V. cabinet), a dark red and gold theater with painted orchestra and patrons, the *Nathaniel Hawthorne Memorial Bookcase* (with seven gables), and her sewing box demonstrate her fine craftsmanship and her ability to make surprising juxtapositions. She tries, she says, to make things come alive–not necessarily to make them funny.

The artist has so much love to give back to the universe that it spills over,
and the fallen drops become 'works of art.' It is love in another form.

Nancy Jackson

Theatrum Vulgarium
T.V. cabinet, dark red
acrylic with gold bas-relief
Red velvet curtains cover
the screen when not in use.

173

PLAY AT WORK

Take a few minutes during your lunch break to play with your office copy machine. You will immediately be able to see things in permutations that would otherwise take hours to imagine or achieve.

The most important thing is to play. Combine unlikely images. Make big things small, small things big. Don't search too hard for materials. Use what you have–your hand, a fork, a leaf, a newspaper, glasses, a rubber stamp, a postage stamp, a soup can, a penny, a piece of fruit.

Enlarge your image until the original content is unrecognizable. Dot patterns from printed photos in newspapers and magazines, when enlarged will make new pictures. Blow up type too, and see what has been hard and sure become soft and lacy.

Reduce and enlarge a single image to make receding crowds or processions. Finish your new art with colored pencils or water-colors. (Markers or oil-based ink will dissolve the image.) Enhance with stickers, gold leaf, glued papers, cloth, beads, rubber stamps, etc.

In addition to paper, cardstock and special transparent acetate sheets that are approved for copier use, some medium to heavy weight tracing papers and parchments also work on most machines. Print both sides of a tracing paper and the image on the back shows through like a ghost print–a pale shadow.

YES

Crumpled foil makes the lower part of the picture; plastic wrap is the upper background. The bird was cut from a Christmas card and the words (from Wings, *by Victor Hugo) were scratched into the background with an Exacto knife.*

IMMACULATE HEART COLLEGE ART DEPARTMENT RULES

Rule 1 — FIND A PLACE YOU TRUST AND THEN TRY TRUSTING IT FOR A WHILE.

Rule 2 — GENERAL DUTIES OF A STUDENT: PULL EVERYTHING OUT OF YOUR TEACHER. PULL EVERYTHING OUT OF YOUR FELLOW STUDENTS.

Rule 3 — GENERAL DUTIES OF A TEACHER: PULL EVERYTHING OUT OF YOUR STUDENTS.

Rule 4 — CONSIDER EVERYTHING AN EXPERIMENT.

Rule 5 — BE SELF DISCIPLINED. THIS MEANS FINDING SOMEONE WISE OR SMART AND CHOOSING TO FOLLOW THEM. TO BE DISCIPLINED IS TO FOLLOW IN A GOOD WAY. TO BE SELF DISCIPLINED IS TO FOLLOW IN A BETTER WAY.

Rule 6 — NOTHING IS A MISTAKE. THERE'S NO WIN AND NO FAIL. THERE'S ONLY MAKE.

Rule 7 — The only rule is work. IF YOU WORK IT WILL LEAD TO SOMETHING. IT'S THE PEOPLE WHO DO ALL OF THE WORK ALL THE TIME WHO EVENTUALLY CATCH ON TO THINGS.

Rule 8 — DON'T TRY TO CREATE AND ANALYSE AT THE SAME TIME. THEY'RE DIFFERENT PROCESSES.

Rule 9 — BE HAPPY WHENEVER YOU CAN MANAGE IT. ENJOY YOURSELF. IT'S LIGHTER THAN YOU THINK.

Rule 10 — "WE'RE BREAKING ALL OF THE RULES. EVEN OUR OWN RULES. AND HOW DO WE DO THAT? BY LEAVING PLENTY OF ROOM FOR X QUANTITIES." JOHN CAGE

HELPFUL HINTS: ALWAYS BE AROUND. COME OR GO TO EVERY-THING. ALWAYS GO TO CLASSES. READ ANYTHING YOU CAN GET YOUR HANDS ON. LOOK AT MOVIES CAREFULLY, OFTEN. SAVE EVERYTHING-IT MIGHT COME IN HANDY LATER. THERE SHOULD BE NEW RULES NEXT WEEK.

David Mekelburg. Corita Kent's Rules & Hints for Students & Teachers

When you drive north on the I-5 freeway between L.A. and Burbank, you parallel the Los Angeles River, which for most of the year is barely damp. But in severe winters, water from the surrounding hills drains into the river bed and sends torrents–two stories high–raging down the river to the sea. After devastating floods in the 1930's, flood control channels were installed. The gates of these are seen halfway up the concrete banks, as the grinning faces of a bunch of mischievous cats. The cats multiply and prosper. When one becomes faded or damaged, it is repainted and a new cat evolves. They have cheered harried commuters for years–and though we don't know who painted the first cat on a flood gate, we want to thank them for starting it all.

177

CELEB

To celebrate: To trumpet, honor, skylark; go places and do things; mark an occasion, bless and sing. To honor or observe with solemn rites or ceremonies; to proclaim: publish abroad, extol, sound the

I would like to lay groundwork by telling the history of one of the celebrations at Immaculate Heart College, Mary's Day–where it came from, how we changed it, and how it led to other things. Then perhaps you can look at the state of your own celebrations and get some ideas of

how to revitalize them or initiate new ones. Mary's Day was a tradition at Immaculate Heart. The school was dedicated to her. The day had originated in another time, and the circumstances of that time had formed it. There was a solemn procession with students dressed in

RATION

praises of; a festival or holiday; herald, commemorate, memorialize, hold jubilee, make merry, kill the fatted calf, beat the drum, laud, pay tribute, eulogize, send praises to the skies.

(from Webster's New Collegiate Dictionary and Roget's Thesaurus)

black academic caps and gowns—only the faculty looked festive in colors from many universities. There was a quiet Mass and sacred music. The seniors each carried a white lily and walked by a statue of Mary, placing the flowers into a vase, eventually forming a large bouquet. There were speeches and awards and a sit-down meal. It was a sincere, respectful, and earnest, if parochial, ceremony. But because it had not had new growth for many years, it was a bit anachronistic and less lively than it should have been. I was commissioned to make the day new.

As with any commission in those days, I started it going and the students did immense amounts of work and shared much of the responsibility. I always started a class (whether it worked toward a large group project or an individual one) with an immense profusion of visual material so that the makers would begin with high standards and new sources. We drew also from the work of former students, the best of which was kept, so that new students could start on their shoulders instead of starting at the bottom.

Ancient celebrations were not frivolous or commercial, although they were of their own time with its limitations and prejudices. I think celebrations are always meant to instruct and inspire, to empower people to use their own creative skills through images and ritual to action.

Words and other symbols were used to create a stimulating atmosphere

that would surround the celebrators throughout the day. We covered windows and doors and retaining walls. Wherever we found a flat space, we filled it with the day's special "news."

Our celebration grew out of a desire to make Mary more relevant to our time—to dust off the habitual and update the content and form. We wanted to enliven a day of the shrunken and habitual to include

many of these rediscovered elements. All art is reflective of its own time as well as containing the riches of the past, and we were in a time of heightened awareness of broader traditions and of the current social events that were shaping our growth.

Corita

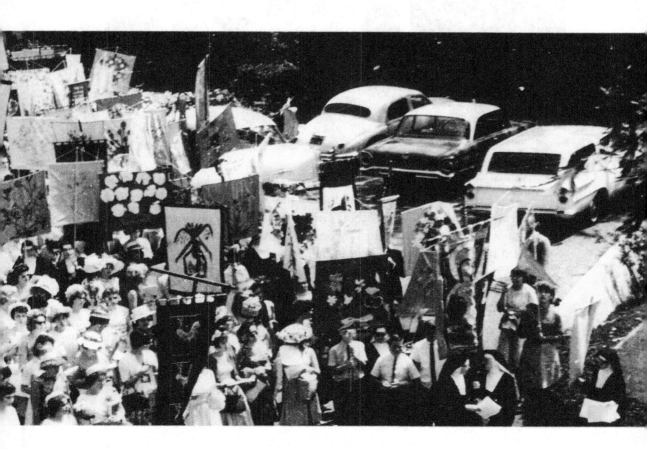

This chapter deals with ideas about group endeavors, large exhibits, and ways to make celebrations. It is about how to make statements–social and personal– and about how to build together. The process for any of these is the same, no matter what the project title may be. Since we like to celebrate, we will talk about how to do that well–how to make a splendid occasion. In this book we don't have the benefit of Corita standing in front of us, reading, showing films, and getting us started, so we will need to do some of this generative source work for ourselves. Your local library is a prime source for your investigations. As well as books, many have films, records, and other research facilities. You should do some research before you begin the assignments.

Descriptions of three celebrations follow that might give you some ideas of where to start or what to do. Though each is a different occasion, their structure and many of the building blocks are the same.

MARY'S DAY

Corita communicated the form and spirit of the revitalized Mary's Day with the
following words:

The function of such a day
is to provide a day of no functioning
a day of general feasting and rejoicing
a day of being with our friends
for one day to show ourselves
as a visible community
marked with extra colors
and extra sounds
a community playing
and singing
and worshipping
and feasting
after which we will go back to our work
refreshed and respirited.

It is also a day to pull loose ends together
about the theme of the school year
Pacem in Terris
an earthly peace
(His will on earth
is worked by men and women).

To make this more tangible
we focus on food
in our own marketplace
where the stuff of life is sold.
We take time out to celebrate
the ordinary stuff of life.
We lift the common stuff—
groceries and signs about groceries—
out of the everyday
and give it a place in our celebration.

details of Corita's serigraphs

When we put them back
into our everyday life
they will be somehow
ennobled on our grocery
shelves and in our kitchens.
When we see them every day
they will remind us of
this good day . . . and
heaven and earth will not
be so far apart.

Ordinary things
will be signs for us
of our neighbors' needs,
of our responsibility.

Corita

Eat first, poetry later.
Chinese Proverb

Many of us have grown up with certain images of Mary, the Blessed Mother. We know her as all-loving and all-suffering, a model of cosmic decorum. We were shown only the faintest smile in old-master paintings of Mary holding her infant son. When I was five, I was asked to leave the room in Sunday school when I asked our teacher, *Doesn't Mary ever laugh or scold her baby?* It seemed odd to me that the Christ Child was never shown being bounced or tickled or thrown into the air by his mother in the special way mothers have–their hands never really leaving the baby's body.

For our celebration Mary would like music and bright colors. Mary would finally laugh.

Our colors are the colors of the marketplace, the colors of life-giving foods, and our sounds are the sounds of the here and now.

Sister Mary William

This was a homemade celebration, with work for everyone. Where we had no traditions, we borrowed them. If we ran out of poetry, we took it from the market–*The Best to You Each Morning, Power Up, Come Alive*–and we made parables from road signs–*Stop, Yield, Right of Way, Slow.*

The organization of the ceremony was the key to success–a careful plan that would be a good blend of light and dark, of movement and stillness, of silence and sound. It was to be expressive and reflective. We tried to make it so that nobody would be embarrassed by too much individual attention. We wanted to belong to the day and to each other.

God respects me when I work but He loves me when I sing.
Rabindranath Tagore

Participants (more than 1,600) walked up the hill to the administration building where the Mass would be held. Banners, slit in the middle for head holes, became vestments to be worn at Mass and were given to all who came. With a trumpet blast, everyone moved into the auditorium.

The plain old stage had on it all the flags of the world. Five hundred loaves of bread and five hundred baskets of fruit were stacked on tables before the altar. People processed to the stage, bringing more food. Newspaper galleys, with their messages of disaster, hung down the walls, grim reminders that our work, to make changes, was heavy. After the Mass the windows were opened all at once and light flooded in. Balloons were let loose from the balcony, and when they were popped open, confetti fell out. The celebrants left the auditorium for the front steps, and with another trumpet blast, the vestments were taken off and hung on sticks that had been passed out–and they became banners. The celebrants were then led in a grand procession by a man playing bagpipes. Pipers have a wonderful way of walking, and we all tried to walk in that proud, rhythmic way.

Besides the piper, a small band joined in as we moved to a large, grassy area where we stopped to feast on the bread and fruit. Our tables were cardboard cartons that had been painted and collaged with the words of the day– the words of Kennedy, King, Gandhi, Pope John XXIII, and others. These same boxes had also been used in parts of the ceremony as walls or structures to walk through.

Banners were made from cloth, paper, and bits of jewelry. They were embroidered, painted, appliqued, and sometimes were three-dimensional. For big banners we used old sheets and laid them out on the ground. When the theme was chosen–trees or flowers–we painted one color at a time on each of them–all the yellow, all the red, all the purple, etc. The vestment banners were one quarter of a sheet. When they were on the ground in front of us and we saw only one color at a time, it was not easy to see the whole. When they were hung or worn, they were very beautiful. The clear statement of the theme and the limited design elements and materials gave a fine unity to the whole affair.

rice fields in Bali

A CREMATION IN BALI

Celebrating the things we wish to remember, commemorate, or draw attention to is to act upon and reflect upon our theme in a ritualistic or ceremonial way. In the West, secular spectacles have been separated from religious ritual–the participant from the spectator–for hundreds of years. We are now a nation of spectators. In Asia, Africa, and in primitive societies, men, women and children build a celebration together. They eat, dance, sing, worship, and walk in procession together. The audience and the performer are one. Celebrating together is one way to experience the "whole" again. This wholeness is a means to a goal and a goal in itself.

The Balinese have much to teach us about the (non) art of celebration. The making of splendid occasions occupies much of their time. If you ask a Balinese what he does, he will proudly answer, *I am a Baris dancer,* or *I am a mask maker.* If you persist and ask again, *No, I mean how do you get your rice?* He loses interest, his voice drops, he may turn away, deciding this is a pretty boring conversation. *Oh that,* he will say.

The Balinese have advantages over us in that they have generations of traditions to help define their tasks.

These accumulated bits of information act as structures upon which they build. In Bali, as in most of Asia, the task of the maker (painter, carver, etc.) is to project the chosen theme in the best possible way—not, as in the West, to project a personal viewpoint or message. Within the framework of tradition and iconography, the Balinese are free to make each event vibrant and alive with new ways of seeing and making. Spontaneity is channeled, not blown away in all directions. Theirs is a society that is tradition-enriched, not tradition-bound.

The Balinese are not attached to their work, and it doesn't matter what becomes of it. The act of offering one's best is the important thing. Cremation towers and their attendant offerings may take months of communal effort to weave, carve, paint, process, and dedicate, and they are then destroyed in a few minutes of roaring flame. Their loss is not regretted. The concern of the people involved is how well the whole affair—towers, orchestras, offerings, processions, priests, and hundreds of participants—serves as a vehicle for the soul of the departed.

Balinese boy

189

Balinese carrying a sarcophagus

My introduction to Bali was through Miguel Covarrubias's classic, *The Island of Bali*. During my trips to Bali, nearly 40 years after its writing, patterns seemed just as he had described them.

All the accouterments of the cremation have complex associations and meanings that dictate their color and form. The offerings are of a bewildering variety and their iconography is the expertise of special Brahmana women. Merit does not lie in the size of the offering or in the value of the materials from which it is made, but in the dedication and sincerity with which it is made and offered. Visual unity is achieved in part by the use of traditional colors associated with each god. The four cardinal points of the compass have colors, too. According to the god–his position, his preferences, his traditional offerings, and myriad other determining associations–the prescribed colors are repeated in banners, flowers, rice cakes, fruit and other foods, and in the plumage of sacrificial chickens.

The great cremation towers
with their cut gold papers
and streamers of silk
also have predetermined
embellishment. Bunches of
paper flowers on the
corners of the tower
represent forests, and
the receding roofs of the
tower represent the
heavens. The higher
the caste, the greater the
number of roofs, eleven
being the most. The base of
the tower is shaped like a
tortoise, which in Balinese
iconography represents the
foundation upon which the
universe rests.

cremation tower

On the eve of the cremation, a grand procession carries the effigy of the dead to the high priest for a final blessing. If the deceased was prominent in the community, the effigy is often carried by the youngest member of the family, dressed in silks and gold, riding on a palanquin and shaded by golden umbrellas. Sometimes a group of beautiful young girls arrayed in brocades carries the effigy on a silver platter. The members of the family are all dressed in their finest silks and jewelry.

After the blessing of the effigy, the procession turns for home, stopping at the family temple for a final prayer. Back at the house there may be performances by *Baris* (warrior) dancers, a *wayang* (shadow play) and a public reading of the adventures of the hero, Bhima, in Hades. Gamelans (orchestras) play all night.

Baris Gdé dancers

A very different feeling pervades the morning of the cremation. There is great anticipation–children run about shouting excitedly. The whole world seems busy and involved with last-minute preparations. (It always reminds me of when I was a child and we attended a solemn midnight Mass, an all-night reading of *A Christmas Carol,* and then the wild Christmas morning when we opened presents and made a wreck of the carefully cleaned house.) People wear their normal clothes. As the corpse is passed from one group of men in the house to another waiting outside, there is a mock battle and the body is very unceremoniously handled–whirled about so that the soul can't find its way back into the house. The tower is led to the cremation grounds by a long rope, one end of which is tied to the platform where the corpse rests, the other end held by family members in the procession. Other members of the procession are holding the rope too, and the whole thing often deteriorates into a wild tug-of-war.

The pyre is lit, usually by the priest. At this point the gamelans all play at once, louder and louder. There is a rush to the tower to try and rescue the silks and other adornments.

By sunset the ashes have been gathered and another, more loosely formed procession begins the walk to the sea–or if that is too far, the nearest river. The ashes are carefully distributed on the water and people begin to drift toward home. The divine evening light is augmented by enormous fireflies.

Jawaharlal Nehru, on his first visit to Bali, said,

> *This must be the morning of the world.*

THE 1984 OLYMPICS

There's no there, there, said Gertrude Stein, describing Oakland. Jon Jerde, the architect, who, with Sussman/Prejza & Co., created the fantastic, ephemeral visuals for the 1984 Olympics, described Los Angeles as being *placeless.* There is no center, no urban form, no great landmark. There are miles and miles of freeway, low, nondescript buildings, and sometimes, on a clear day, spectacular views of the ocean and surrounding hills. The main focus of the Olympics was to be the Coliseum, a huge, dingy structure that had been built for the 1932 games. It is located in the south central district of Los Angeles amid acres of park, flanked by blighted commercial and residential areas, and by the University of Southern California, whose well kept grounds and affluent buildings make little impact on the heavy, old Coliseum. This area is an example of the peculiar, sporadic nature of the Southern California landscape. The city was hard to unify, yet the job was to make Los Angeles not just a place, but The Place.

To further complicate matters, the budget was very low, the sites were scattered from San Diego to Santa Barbara, and new construction was impossible. The successful solution to these, as well as a myriad other problems, won for the Jerde Partnership and Sussman/Prejza nearly every major design award in the world.

sona tubes

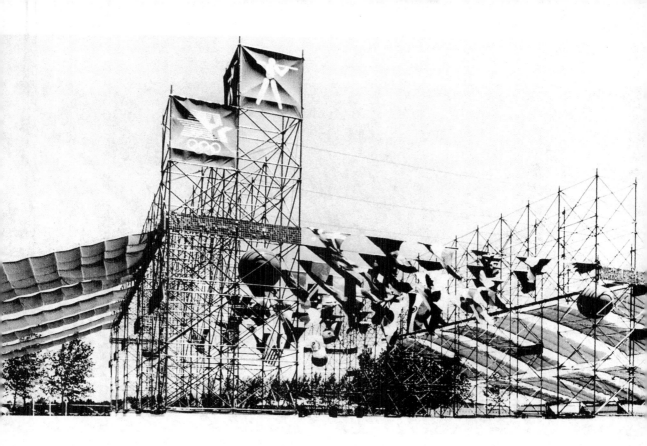

Deborah Sussman had worked for Charles and Ray Eames and through them had been to India and knew Immaculate Heart College. When I asked her how she envisioned the Olympics, she said, *Somewhere between India and IHC* (This is the work of an artist–as she experiences new images and ideas, they get filed away and then brought out again to apply to the task at hand.)

The theme, *Festive Federalism*, was expressed with the use of a limited color palette. Hot magenta was the basic color. Chrome yellow, vermilion, and aqua were next in importance. Light blue, pink, lavender, and yellow were used least often. Generally, the colors were to be used in combinations of three or more. They were not to be used in rainbows; shades of the same colors were banned, as were red, white, and blue. White was used for designs or as background. In a few cases, black was used. Color relationships were to be warm with cool. Shapes of design elements were limited and had their own guidelines. Elements and materials from which the visuals were made were ephemeral. The ancient, ponderous image of the Olympics was given joyful life and light by ingenious use of paper, cloth, cardboard and rented scaffolding.

Each site had a specific color, and while banners and flags flew throughout the city, the density and specific colors intensified as one approached the activity center. The whole city shimmered with unearthly color as the California sun shone through the transparent nylon of the banners and yards of horizontally hung nylon strips which were used to shade rest areas. People under these were tinted with luminous shades: vermilion nylon–pink people. Our days were marked by pockets of color.

One of my assignments was to design the exterior of the swim stadium bleachers. I was completely intimidated. Banners and flags were one thing, but a structure 120 feet tall was quite another. Late one night, sitting beside a wastepaper basket that was overflowing with rejected ideas, I glanced at a small piece of embroidered textile from India that hung on the wall above my drawing board. The linear quality of the textile reminded me of the linear structure of the bleacher scaffolding. The textile had round mirrors embroidered in it, and I remembered that boxes of small plastic mirrors had been donated to the Olympics. I thought they could work to represent the mirrors on the bleachers. The rows of embroidery, translated to the bleachers, became streamer lines of various simple shapes using the Olympic colors. These streamer lines, and others designed later, were used not only in the

*basic shapes
of textile
echoed
in detail
of bleachers*

swim stadium, but at Lake Casitas and to define pathways, hang across streets, enclose or cut off areas, and serve as fillers when an area looked sparse.

The morning after I made my tiny drawing of the immense bleachers, I was afraid it was a terrible mistake. It looked too simple. But everyone liked it, and the design did translate well to the bleachers. My drawing had been, as nearly as I could make it, a simple duplication of the textile. Good design is good design–and I thanked a woman in India, whose name I will never know, who had made that beautiful piece for her daughter's dowry.

The success of the design for the Olympics was demonstrated brilliantly in the television coverage. The graphics–thousands of banners, flags, streamers, pillars, tents, arches, colors, and structures–served to unify, yet they remained an environmental background, in which the athletes, the people who were participating, were always the most important element.

There was no smog, unseasonable heat, or rain (which would have been disastrous for all the paper and cardboard). Freeway gridlock never materialized–in fact, traffic was very light because people took special buses and working hours were staggered. Crime was down, and there was a spirit of welcome and generosity. We were, at last, so proud of our beautiful city.

IT'S BETTER TOGETHER

Celebration is a kind of food we all need in our lives, and each individual brings a special recipe or offering, so that together we will make a great feast. Celebration is a human need that we must not, and cannot deny. It is richer and fuller when many work and then celebrate together. Celebration is not exclusive–it is the most inclusive human act, and it is one of the things that separates human from animal. If you have ever attended a *gymanfa* (assembly) *ganu* (to sing)–the Welsh music festival where as many as five thousand people are joined in song–you will have a pretty good idea of a splendor greater than the sum of its parts. If you have ever sung in one you know in an even deeper way, the nourishment we draw from each other.

Korean festival

Celebration is built on a ritual or pattern of action that we choose for ourselves. We are, for once, in charge of what's happening, and we are free to be spontaneous within that pattern. We are together in a very trusting way. Celebration makes a small space and time in which we are safe and supported.

Celebration takes ordinary things and puts them into an unusual context for a short, intense time. We see the essence in each and relate them to our theme. Later we will be reminded of a happy time and its deeper meaning when we see them back in their usual place.

When we are immersed in the experience of celebrating together, we may be nameless, our part (to others) unclear, but we will be an essential ingredient in what e.e. cummings calls *a joy that wasn't and isn't and won't be words.*

Many of the same ingredients occur in all celebrations. The following are some of the things held in common by Mary's Day, the Olympics, and the cremation.

A central theme.

Special colors: the Olympic palette, Balinese caste colors, and the Mary's Day colors reflecting the marketplace.

Special words: Let the games begin, the words of the Balinese priest, the Mass and speech of Sister William stating the theme.

Special clothes.

Special music.

Fire: the Olympic torch, the cremation, and the candles at Mass.

Ephemeral materials: paper, cloth, flowers.

Processions.

Symbolism: things that transcend the earth: flags, banners, birds, balloons.

A tightly structured plan: beginning, middle, climax, and end.

assignment

wedding cake, USA

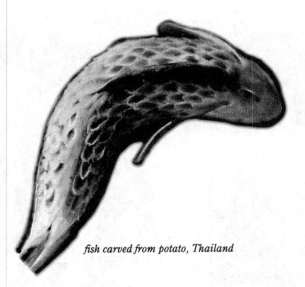

fish carved from potato, Thailand

Make a celebration.

Before you begin your work, gather books and other materials about celebrations in other cultures and countries. Listen to the music used for these events–to recordings of Balinese gamelans, of Balkan singers, and music from the Western world that came about from the need to mark special occasions, rather than that which was composed for entertainment. Find cookbooks that give recipes for special feasts–Russian Easter, the New Year in China, or a wedding in Italy.

pan dulce, Mexico

Make a very free list of everything you associate with celebration. Set a time limit–say three hours. Involve as many people as you can–a variety of viewpoints will make a more richly textured event and will provide more solutions. Don't judge whether the list makes sense or seems relevant.

Organize the list you have just made into specific groupings.

What events in our world today can be acted on in a ceremonial or ritual way? In this group, put every reason to celebrate–rite of passage, the cure of some disease, the release of a prisoner, etc.

Theme–include the message as well as the purpose of the celebration. Find literary and other word sources to express the message.

Material things that make you feel good–food, clothing, music, etc.

What ceremony will be performed? Ceremonies are formal acts, often symbolic, that are structured–and will make the structure for your celebration. These ceremonies are usually traditional. Borrow good ideas from other traditions and adapt them to your own needs.

Ceremonies often deal with change–from competitor to champion, the release of the soul, the joining of two people. The moment of change is the most climactic part of the event–the fire is lit, the birds released, and a great cheer follows them to the sky. How will this be expressed?

ritual feast, Korea

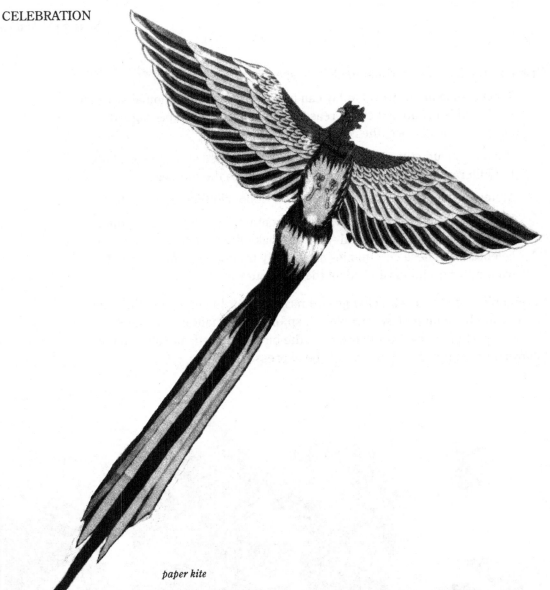

paper kite

After you have organized the ceremony, the physical and material aspects of the celebration will follow the established needs of the event. Brainstorm ways to make the principal statements for the ceremony. For example, if you don't have any doves or balloons, then banners with birds painted on them, all raised at once, could say the same thing. There is power in multiples. The more people you have working on the project, the more ideas and skills are available. The more banners raised, the stronger the image.

For the Olympics, pre-designed shapes in different colors were assembled in various ways—combining different elements—to mass produce the thousands of banners and flags that were a major decorative element. Banners using the sample kit of modular banner templates shown here could be made of paper or cloth and embellished with paint, stitchery, silk-screen patterns, and rubber stamps. Silkscreen, rubber stamps, and other printmaking processes are most appropriate for reproducing the same images in multiples.

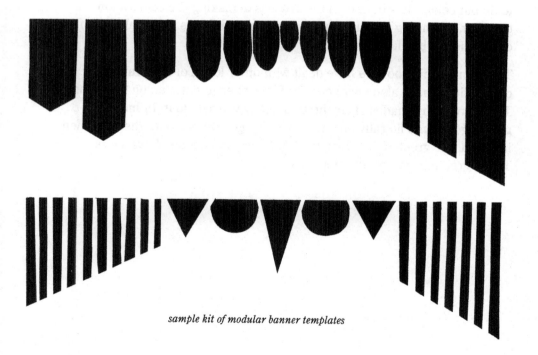

sample kit of modular banner templates

BHAVA AND RASA

These two Sanskrit words can help clarify our task. They are at the very core of making a good celebration. *Bhava* is the pure emotion or sentiment that the dancer, musician, painter, or other artist intends to portray and express. *Rasa* is the essence, the juice, received from the projection. *Bhava* is the theme, in its deepest, fullest sense, and *rasa* is the message received. Rather than using a lot of words, we can use *bhava* and *rasa*.

Just when you think everything is about finished, please make one more list, keeping in mind *bhava* and *rasa*. What are the emotional, intuitive aspects of your theme, and how can they best be projected? This question calls for a kind of deep probing that can't be answered intellectually. One way to do this is by making a list so long that before you are half through it, you will have written down all the conscious material. That cleared away, the deeper, more subtle material can begin to float free. Write down everything. The connections will be there. Trust this process and you will find that you know a lot more than you think you know.

When the lists are made, the ceremony choreographed, material and visuals complete, music chosen, and food prepared, there's nothing left to do but celebrate–though, in the process of making the celebration together, a bonding has already taken place, and that is a special kind of celebration in itself.

Throughout this book we have dealt with other kinds of celebration–celebrations made alone with care and love to send out, person to person. There are many shades of celebration, many ways to do it. In India, the greeting *namaste* literally means *I greet the light in you*. With the Bushmen in Africa, the greeting is, *I was dead, but now you've come, I live again*. These greetings are celebrations, too.

Namaste

I greet
the light
in you

Corita

BIBLIOGRAPHY

At IHC, art majors were required to be English minors. We read the classics, folk tales, and contemporary literature; histories of people, toys, textiles and various crafts; and, of course, books on art. Sister Mag instructed us to carry Janson's *History of Art* with us at all times–she didn't think we would read it, but hoped we might absorb something by its presence and bulk, or that in odd moments we might glance through and pick up some bit of wisdom. In addition to the titles listed below, we were encouraged to read the complete works of William Blake, e.e. cummings, Isak Dinesen, T.S. Eliot, Robert Frost, Archibald MacLeish, Sean O'Casey, Rainer Maria Rilke, Wallace Stevens, Gertrude Stein, and John Synge, as well as the Bible and the Bhagavad Gita.

Ashton-Warner, Sylvia
SPINSTER
Simon & Schuster, 1986

Campbell, Joseph
HERO WITH A THOUSAND FACES
(Rev. Ed.)
Princeton University Press, 1968

Caplan, Ralph
BY DESIGN: WHY THERE ARE NO
LOCKS ON THE BATHROOM
DOORS IN THE HOTEL LOUIS XIV
& OTHER OBJECT LESSONS
St. Martin's Press, 1982

Chalfant, Henry and James Prigoff
SPRAYCAN ART
Thames & Hudson, 1987

Coomaraswamy, Ananda K.
TRANSFORMATION OF NATURE
IN ART
Dover Publications, 1937

Covarrubias, Miguel
THE ISLAND OF BALI
Routledge, Chapman & Hall, 1986

Friedman, Maurice S.
MARTIN BUBER: THE LIFE OF
DIALOGUE (3rd Ed.)
University of Chicago Press, 1976

Janson, H.W. and Evelyn Phillips
HISTORY OF ART (3rd Ed.)
Prentice Hall, 1986

Keene, Donald
JAPANESE LITERATURE: AN
INTRODUCTION FOR WESTERN
READERS
Grove Press, 1955

Levy, Dana *et al.*
KANBAN: SHOP SIGNS OF JAPAN
John Weatherhill, 1983

Maritain, Jacques
(trans. Joseph W. Evans)
ART AND SCHOLASTICISM
University of Notre Dame Press, 1974

Milne, A.A.
THE POOH STORY BOOK
E.P. Dutton, 1965
Moholy-Nagy, Laszlo

VISION IN MOTION
Paul Theobald & Co. 1947

Nicolaides, Kimon
THE NATURAL WAY TO DRAW
Houghton Mifflin Co., 1975

Oka, Hideyuki
HOW TO WRAP FIVE MORE EGGS
John Weatherhill, 1975

Pearce, Joseph Chilton
MAGICAL CHILD
Bantam Books, 1980

Streeter, Tal
THE ART OF THE JAPANESE KITE
John Weatherhill, 1980

Ueland, Brenda
IF YOU WANT TO WRITE (2nd Ed.)
Graywolf Press, 1987

Van der Post, Laurens
THE HEART OF THE HUNTER
Harcourt Brace Jovanovich, 1980

Wacziarg, Francis and Aman Nath
RAJASTHAN: THE PAINTED
WALLS OF SHEKHAVATI
Abner Schram, Ltd., 1983

Zukav, Gary
THE DANCING WU LI MASTERS
Bantam Books, 1980

Part of our daily fare in the art department at IHC were films by Charles and Ray Eames–from *Blacktop,* which shows the washing of a school yard accompanied by music of Bach, to *Day of the Dead,* a description of the Festival of Death in Mexico; from *Textiles and Ornamental Arts of India* to *Toccatta for Toy Trains.* For further information on the availability of these and other Eames films and video cassettes, contact Pyramid Films, Post Office Box 1048, Santa Monica, CA 90406.

We also watched *Corita on Teaching/on Celebration,* a film by Baylis Glascock that includes "We Have No Art," "Mary's Day," and an interview on Corita Kent's 50th birthday. For information on the availability of this film, contact Baylis Glascock Films, 4503 Radford, North Hollywood, CA 91607.

CODA

Identification of specific chapters as they relate to the National Frameworks and Standards for the Visual Arts

The mind can be a noisy and cluttered place that can drown out the heart. Sifting through a maze of standards and frameworks for the visual arts could add to the noise and distract from the experience. Beginning with the rules or the words to create the art can lead to a dead end and muddy the search for what genuinely touches the artist. It's easy to get caught up in the verbiage trying to get it right. I offer this caution as a reminder that making and creating *are* the real thing, the words that describe them are secondary.

So take a leap and dive in, try out the assignments in this book in the spirit of playfulness and exploration because that's they were created to inspire. Trust that these genuinely creative activities inherently bring to life the vision behind the Frameworks and Standards for the Visual Arts. Then consult the chart at the end to discover precisely how they did that. You will find the language educators must understand and master in order to articulate to others the value of what we know in our hearts.

Putting your conscious (and critical) brain on hold can allow creativity to seep in–unfettered. It takes a little courage to shift gears and just "do" or "be." When students judge themselves as taking a wrong turn proclaiming, "I messed up," I ask them to describe what this means. Eventually we discover that the preconceived picture in their head doesn't match what they now see before them. I congratulate them on stumbling upon "a happy accident"–a magical incident in which the artwork is taking on a life of its own and talking back to them. I encourage them to let go of the picture in their head and get to know the picture before them–to discover where the artwork is leading them, if they are willing to pay attention. With a little courage and the permission to "give it up," they often surprise us both with their creations and fresh discoveries. Likewise, I invite you to do the activities/assignments without a picture in your head, so you won't have the chance to "mess up." Simply look back in wonder to see where you've been.

Traveling over freeways, city streets, dirt roads, and mountain passes, I'm reminded of the windy roads that can take you to the same destination. I'm also aware of the beauty of the journey and the surprises along the way. As a student, teacher, artist, and administrator, I've visited many classrooms over

the years. In some classrooms, the richness of the journey is evident in artwork that seems to vibrate with an energy all its own. In others, the journey is a prescribed trudge with no veering off the path.

Susan A. Friel
January 2008, Chicago, IL

In 1994, the National Standards for Arts Education were published as a guide to developing proficiency in the arts. Six basic principles were identified to comprise a well-rounded education in the visual arts. The states, school districts, and ultimately teachers are the ones who must bring these concepts to life for their students. The goal of this book is remove the constraints that prevent us from expressing ourselves as individuals. Viewing this goal as a well-balanced meal, we can select from the ingredients in this book and the accompanying chart to nourish creativity.

Listed below are the National Standards for Arts Education.

Visual Arts Content Standard 1. Understanding and applying media, techniques, and processes.

Visual Arts Content Standard 2. Using knowledge of structures and functions.

Visual Arts Content Standard 3. Choosing and evaluating a range of subject matter, symbols, and ideas.

Visual Arts Content Standard 4. Understanding the visual arts in relation to history and cultures.

Visual Arts Content Standard 5. Reflecting upon and assessing the characteristics and merits of their work and the work of others.

Visual Arts Content Standard 6. Making connections between visual arts and other disciplines.

Learning by Heart
Connecting to the National Frameworks and Standards for the Visual Arts

	1. Understanding and applying **media, techniques and processes**	2. Using knowledge of **structures and functions**	3. Choosing and evaluating a range of **subject matter, symbols and ideas**	4. Understanding the visual arts in relation to **history and cultures**	5. Reflecting upon and assessing the **characteristics and merits** of their work and the work of others	6. Making connections between visual arts and **other disciplines**
LOOKING						
Assignment 1	●					
Assignment 2	●					
Assignment 3	●	●				
Assignment 4	●					
Assignment 5	●					
Assignment 6	●					
Assignment 7			●			
Assignment 8	●		●			
Assignment 9			●			
Assignment 10	●		●			
SOURCES						
Assignment 11					●	
Assignment 12				●		●
Assignment 13				●		●
Assignment 14						●
Assignment 15	●	●	●			●
Assignment 16					●	●
STRUCTURE						
Assignment 17	●	●				
Assignment 18		●				●
Assignment 19		●	●			
CONNECT & CREATE						
Assignment 20						●
Assignment 21						●
Assignment 22						●
Assignment 23	●		●			●
Assignment 24			●			
Assignment 25			●			
Assignment 26				●		
TOOLS & TECHNIQUES						
Assignment 27	●					
Assignment 28	●					
Assignment 29			●			
Assignment 30	●	●				
Assignment 31	●	●				
Assignment 32				●	●	●
WORK PLAY						
Assignment 33		●			●	
Assignment 34		●				
Assignment 35	●					
CELEBRATION						
Assignment 36	●	●	●	●	●	●

ACKNOWLEDGMENTS

"It has been a lonely job to finish this book and I couldn't have done it without the help of my friends and family." These were the words with which I began acknowledgments twenty years ago. This second edition begins differently–with gratitude and happiness for the loving support from so many new friends as well as those from long ago who have stayed with me.

From the beginning Ray Eames was a source of comfort, inspiration and common sense. She made available to me the sources and resources of the Eames Office and, equally important, would whisk me off for surprise visits to our favorite restaurant and joss shops in Chinatown. Her delight in everything–from wrappings on the cheap incense packages to the shapes made in our bowls of steaming noodles–always gave me light and hope.

Therese Gorman-Steward's strength, energy, incisive mind, technical expertise and artistic sensitivity were of immeasurable value in every part of the job. She assisted me with illustration, writing, editing, and production, and to date, has presented me with two beautiful grandchildren.

Josephine Pletscher was always there to help. She provided many photographs including valuable documentation of the early days at IHC and she drew the title for *Looking*. She served as my major source for research, as organizer, master of gentle critique, and true friend.

Norine Dresser, Nancy Jackson, Fahim Zand, Dale and Jon Gluckman, Janet Williamson and Leno and Paul Suslin let me take apart their homes in order to find things to photograph for this book. The Sislins loaned me their beautiful daughter, Caitlin, who drew for me, and Janet's son, Gavin, played with puppets for me to photograph. Frank Downey, Corita's brother-in-law, was a very patient gentleman who never let on that he was getting tired of my constant questions. Deborah Sussman, Paul Prejza and Annette Del Zoppo made available Olympic material. Marlene Teel and Louise Davis gave me a grant, which made it possible to hire Janine Poche and Christie White. Patty Maloyan gave loving care to the horses and dogs.

Marie Sansone retyped ragged notes and turned them into consecutive pages. Christopher Reed read many drafts, contributing greatly to continuity

and clarity. Sally Turner assisted with proofing and editing. Lauren Cowdery came from Connecticut to edit, type up a storm, and support me with her love and compassion. As we worked, her husband, Jim, filled the house with Irish music and the fragrance of spicy curries.

Thank you to Patricia Altman at the UCLA-based Fowler Museum of Cultural History for facilitating photography there. Thanks to Mel Helstein, also of UCLA, for his descriptions of puppets. In India, Ashoke Chatterjee and Haku Shah read manuscripts and shared and corroborated sources. Great thanks to Shanti Dave for being the patient source, friend, and guide. In Java, Han Resink, with the wisdom of the very ancient soul he is, replaced my confusion with light.

I thank the former IHC students who responded to my questionnaire which became the beginning of the book. Former IHC students Mary Marks, Paula Rao, Sister Karen Boccalero and Lita Clearsky gave hours of valuable assistance–as did Pat Ostrow and Joan Kolostian, who were superb cheerleaders. Kathy Mason's third grade class made the "Faerie Queen" wall for the book. Micky Myers helped long-distance from Boston, and John Swanson came to help whenever I called. David Meckelburg contributed the calligraphy chapter titles for *Celebration* and *Connect & Create*.

My family, Herb, Tina, Alan, Sean, and Therese put up with the chaos of 14 years to produce the first edition. This time, Herb has left us, but grandkids Kaitlin, Morgan, and Lottie Rae have joined me–adding to my life what Gerard Manley Hopkins called "All this juice and all this joy."

Much of the support for this edition came from friendships of the past. Paula Rao designed the type for the book cover and shared her brilliant perspective. Barbara Loste came from Spokane to stay with me and work 24/7–writing, editing, advising, cooking oatmeal, and walking the dog. She always knows what is needed and supplies that perfectly. Baylis and Kathy Glascock advised and assisted–again–in many ways, as did Marilyn Phillips.

This time, Julie Ault contributed her fine mind to offer advice, terrific plans and loving support along with Ravi GuneWardena and Frank Escher. Sasha Carrera at the Corita Art Center gave hours of hard work, as did her assistant, Corrie Siegal. Graphic designer Juliette Bellocq came to the rescue of the covers as well as gently correcting mistakes I never saw.

This edition couldn't have happened without Joshua White. Even more than his magnificent gift as photographer of arts and architecture is his gift of self–his time, genius, and compassion. Susan Friel gave of her precious experience to relate the book to contemporary educational requirements and to nourish great positive curiosity in many areas and ways.

It was a tremendous joy to work under the supervision of the brilliant editor, Toni Burbank, at Bantam. I thank those at Allworth Press for bringing *LbH* to life again. Tad Crawford, Katherine Ellison, Melanie Tortoroli, and Janet Robbins, with confidence and patience, guided me kindly through a complex journey.

Profound gratitude to Rev. Masao Kodani who taught me about Krazy Kat's experience with the light switch.

My great love and thanks to Margaret Martin (Sister Mag) for starting it all, for helping me keep perspective and a sense of humor. She was a brave and awesome friend.

And thank you, Corita, for the billions of treasures you gave us all.

J.S.

CREDITS

Photographs and drawings are by Jan Steward except for the following.

JAN STEWARD is a California artist whose professional career and professional interests are united in her devotion to Asian art. She has served as the Art Director for the American Society for Eastern Arts, as a board member for the Center for World Music in San Diego, and as a founding member of the Music Circle in Los Angeles. Her photography of Asian arts and artists has won her international recognition. Ms. Steward's work has included painting live elephants for Hindu celebrations (and the Academy Awards), field work in India, Bali, Japan, and Sri Lanka, the design and photography for four books, more than twenty album covers and cassette covers, and work on several films dealing with Asian art forms.

As a graphic designer for George Harrison and his wife, Olivia, Ms. Steward has created amazing things, including a 24-foot-long birthday card for Ringo Starr.

A student of Corita, Ms. Steward frequently served as a substitute for her teacher, supplied text for her serigraphs, and acted as a research assistant. Other design projects include banners and flags for the 1984 Olympics, papier mâché structures in Rochester, New York, and Philadelphia, stage sets, and exhibitions of Indian art. Jan Steward lives in Los Angeles.

BARBARA LOSTE was an art student of Corita's at Immaculate Heart College when she met Jan Steward. The day she graduated, Barbara left for Latin America where she lived for 18 years working as a designer and curator in both Mexico and Chile. She directed the Library of Congress bilingual exhibition *1492: An Ongoing Voyage* in Washington, D.C.

Barbara has designed projects for sustainable development in Central America and the Caribbean and has taught at the university level. She has an MA in Communications & Latin American Studies from the UNAM, Mexico City, and a PhD in Leadership Studies from Gonzaga University. Her dissertation (2000) was a biography of her former teacher, Corita Kent.

SUSAN A. FRIEL is a bilingual educator and artist. After graduating from Illinois Wesleyan University with a Bachelor's Degree in Fine Arts, Susan began working at The Art Institute of Chicago while continuing her education at The School of the Art Institute.

Susan taught in the Unified School District and at Inner-City Arts in Los Angeles, where she met Jan Steward, and developed programs that used *Learning by Heart* as an indispensable guide. As Director of Education for A.R.T. (Art Resources in Teaching) Susan led teaching artists to deliver art programs to children, parents and teachers. Susan used the same philosophy when she taught in Ethiopia and Spain.

Books from Allworth Press

Allworth Press is an imprint of Allworth Communications, Inc. Selected titles are listed below.

The Quotable Artist
by *Peggy Hadden* (7½ × 7½, 224 pages, paperback, $16.95)

The Artist's Guide to Public Art: How to Find and Win Commissions
by *Lynn Basa* (6 × 9, 256 pages, paperback, $19.95)

Selling Art without Galleries: Toward Making a Living from Your Art
by *Daniel Grant* (6 × 9, 256 pages, paperback, $19.95)

The Business of Being an Artist, Third Edition
by *Daniel Grant* (6 × 9, 352 pages, paperback, $19.95)

The Artist-Gallery Partnership: A Practical Guide to Consigning Art, Third Edition
by *Tad Crawford and Susan Melton* (6 × 9, 216 pages, paperback, $19.95)

Fine Art Publicity: The Complete Guide for Galleries and Artists, Second Edition
by *Susan Abbott* (6 × 9, 192 pages, paperback, $19.95)

Legal Guide for the Visual Artist, Fourth Edition
by *Tad Crawford* (8½ × 11, 272 pages, paperback, $19.95)

Business and Legal Forms for Fine Artists, Revised Edition
by *Tad Crawford* (8½ × 11, 144 pages, paperback, includes CD-ROM, $19.95)

Guide to Getting Arts Grants
by *Ellen Liberatori* (6 × 9, 272 pages, paperback,$19.95)

The Artist's Complete Health and Safety Guide, Third Edition
by *Monona Rossol* (6 × 9, 416 pages, paperback, $24.95)

Artists Communities: A Directory of Residences that Offer Time and Space for Creativity
by *the Alliance of Artists Communities* (6 × 9, 336 pages, paperback, $24.95)

Creative Careers in Museums
by *Jan E. Burdick* (6 × 9, 224 pages, paperback, $19.95)

Caring for Your Art: A Guide for Artists, Collectors, Galleries and Art Institutions, Third Edition
by *Jill Snyder* (6 × 9, 256 pages, paperback, $19.95)

CPSIA information can be obtained
at www.ICGtesting.com
Printed in the USA
LVOW04s0521100317

526649LV00006BA/19/P